S0-BYW-839

S0-BYW-839

CREATIVE PAINTING FROM PHOTOGRAPHS

CREATIVE PAINTING FROM PHOTOGRAPHS

BY RUDY DE REYNA

WATSON-GUPTILL PUBLICATIONS/NEW YORK
PITMAN PUBLISHING/LONDON

Copyright © 1975 by Watson-Guptill Publications

First published 1975 in the United States and Canada by Watson-Guptill Publications,
a division of Billboard Publications, Inc.,
One Astor Plaza, New York, N.Y. 10036

Library of Congress Cataloging in Publication Data
De Reyna, Rudy, 1914–
 Creative painting from photographs.
 Includes index.
 1. Painting from photographs. 2. Painting—
Technique. I. Title.
ND1505.D46 751.4 74-23815
ISBN 0–8230–1092–9

Published in Great Britain by Sir Isaac Pitman & Sons Ltd.,
39 Parker Street, London WC2B 5PB
ISBN 0–273–00906–0

All rights reserved. No part of this publication
may be reproduced or used in any form or by any means—graphic,
electronic, or mechanical, including photocopying, recording, taping,
or information storage and retrieval systems—without
written permission of the publishers.

Manufactured in U.S.A.

First Printing, 1975
Second Printing, 1975

For Connie

Contents

Acknowledgments 8

Foreword 9

Materials and Equipment 10

Shooting Source Material 20

Enlarging the Photograph 26

1. Squaring-Up 27
2. Opaque Projector 33
3. Camera Lucida 39
4. Pantograph 44
5. Visual Approximation 49

Composing Your Picture 52

6. Combining Several Photographs 53
7. Photographs and Sketches 62
8. Multiple Prints from Same Negative 68
9. Sequential Photographs for Panorama 75
10. Altering Values 81
11. Correcting Photographic Distortion 87

Painting from Photographs 95

12. Landscape from a Black and White Photograph 96
13. Landscape with Simplified Details 100
14. Landscape with Fleeting Lighting Effects 104
15. Night Landscape from Daylight Photograph 108
16. Seascape Modifying the Color of Original Photograph 112
17. Seascape with Rapidly Changing Details 116
18. Portrait from Photographs and Sketches 120
19. Still Life from Color Slides 124

Experimenting with Photographs 129

20. Photographs from Television 130
21. Abstract Design from Photographs 137
22. Stop-Action Photographs 145

A Parting Word 153

Index 155

Acknowledgments

I'm most grateful to Barbara Russell
and John Houston for their photography
and for their cooperation
in countless other ways.

Foreword

The use of photography by the painter is an old subject that at times gets a bit touchy. When the camera first came to the aid of the artist around the middle of the last century, most established painters welcomed it as an ally. To the public, however, using a photo always smacked of trickery and deceit; a crutch to support insecure draftsmanship. This is the misconception I hope to dislodge with this book.

There is a growing number of modern masters who depend in one way or another on the photograph. This is as it should be; only Philistines sneer at the advances of technology. Today there are no cobblers making shoes by hand, no wheelwrights, or coopers or chandlers. Yet the painter refuses to cast off the dead skin of the past and thinks he must be eyeball-to-eyeball with nature if he's to be inspired. Silly, I think, and I include myself in this group, because until recently I thought so too. Having spent the greater part of my life in commercial art, the photograph is no stranger to me, but steeped in the traditions of the old masters, I naturally assumed it wouldn't be cricket to use it in the high sphere of the Fine Arts!

Of course, this is wrong; the photo was used by many famous artists — Delacroix, Courbet, Degas, Cézanne, Toulouse-Lautrec, Corot, Utrillo, Picasso. Note that I said "used" and not "copied." A photo is source material to be sifted, arranged, and modified. It can even take the place of the study and sometimes the sketch. The key to creative painting from photos is a responsiveness to the visual world and at least a nodding acquaintance with the craft of painting. In this book I've concentrated on realistic figurative painting because it's my mode of expression, but it doesn't mean that the camera can't be of service to Impressionism, Surrealism, Abstractionism, or any other "ism" you may contemplate.

So gather those snapshots you have around the house and let me show you that creative painting is within your scope. It's only a matter of selecting the elements from one, or combining two or more photographs to make a vigorous visual statement. It also entails the rearrangement, the deletion, or addition of subject matter to heighten a concept and to reinforce a composition. The fundamentals of line, tone, form, color, and texture will be discussed as they occur in the projects ahead.

I hate long introductions and I'm sure you do too, so I'll end now with this admonition: the public who gaze upon your work aren't interested in how it was done, but care enormously what it has to say, and this depends on you.

Materials and Equipment

The basic painting equipment can be set up in any room, preferably, of course, one with a window facing north. For night work, a lamp can be clamped to the drawing board itself or nearby. Fluorescent tubes, either hanging over the board or secured vertically to the window frame can also be a good source of light. The purpose of having everything permanently set up is so that work can be done on the spur of the moment, without the bother of fetching things from the cupboard every time you feel like painting. And if you have the basic equipment invitingly arranged, chances are that you'll dip into the tempera instead of the *TV Guide*.

I recommend that you consult an art supply store catalog for the type of drawing table, easel, or taboret that suits your particular needs. I use an iron-based table with a 30″ × 40″ (76.2 cm × 101.6 cm) board (shown below), which can be raised or lowered by means of a clamp, and can be tilted to whatever slope I want by simply pushing down or pulling up the edge next to me. My taboret is more capacious than it looks, even though it has only one shelf and a deep drawer with a sliding tray over it. Besides a drawing

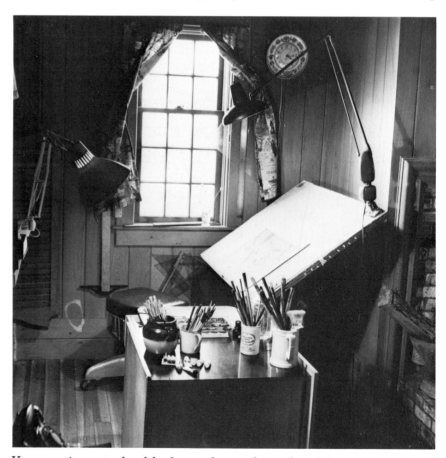

Your equipment should always be ready and waiting — note that it doesn't require much space. Here you can see my drawing board (and how I've attached a draftsman's lamp to it), and my taboret holding the butcher's tray, brushes, and paints.

board, taboret, and comfortable chair (unless you stand up to work), you yourself are the best judge of exactly what further equipment you'll need and which media you prefer to work in. The only advice I have is, as you work, and the need arises for a particular tool, make a note of it and *get it*. This may be anything—from the right brush to a piece of sponge. A carpenter or a mechanic wouldn't be so rash as to tackle a job without the proper tools; why should you?

Cameras

Somehow my dim faculties concerning anything mechanical could never cope with any camera but the Instamatic, by Kodak (A). Bless the chap who resolved all the problems, and left me the fun of just taking aim and pressing the button. Such simplicity of operation means forfeiting some potentially exciting shots, such as night scenes or moving objects, but to gather source material for most outdoor subjects, this marvelous little box has no peer.

The Polaroid, or Land, camera (B) is another godsend because of its simple operation and the instantaneous results it gives. I use the 210 model, but there are many others that perhaps would suit you better. What can be more advantageous than taking back to the studio—not a roll of film to be processed—but the actual photos with whatever information is required.

I purchased a Nikon camera (C), because of its deceptively simple appearance, but soon discovered it demanded more expertise than I had. Perhaps if I had persevered, I would have mastered the camera and the results would have been astounding, but I'm really only interested in photography as a means to an end—source material for my paintings. However, my photographer tells me it's a terrific camera, so don't let me influence you—I'm sure that with one glance at the manual, you will be off and clicking away like a professional!

Film

Black-and-white and color film for the Instamatic can be bought in rolls of 12 or 20 exposures. The film is contained in cartridges that you simply drop into position and your camera is ready for action. The only other concern is to specify the proper film for slides or prints. The Polaroid Model 210, which I use in this book, takes Kodak 3000 speed, type 107 for black-and-white prints, and 75 speed type 108 for color. The manual that comes with each model

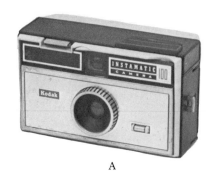

A

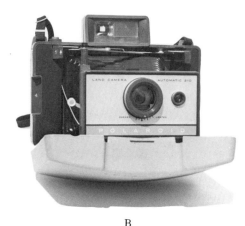

B

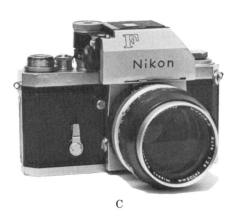

C

The Kodak Instamatic Model 100 (A) is my favorite camera because it's so easy to use. I also like the Polaroid Land Camera Automatic 210 (B), because it's so helpful to see how and if your photo captured exactly the detail or effect desired. The Nikon (C) is reputed to be one of the best cameras available because of its versatility and the high-quality photographs it produces.

should be checked when buying film, but if it gets misplaced, stores selling photo supplies usually have a chart describing the type of film needed for each particular camera model. There are times when a black-and-white photograph is preferable (for example, if you plan to follow a monochromatic color scheme), but as a rule, color film is much better for our purposes. The Nikon, and similar cameras, take Ektacolor type "S" film for prints, and Kodachrome II for slides.

Film can be taken to a photo supply shop to be developed; the shop, in turn, often sends it on to Eastman Kodak. You could, of course, simply take the film to the local drugstore with instructions as to the size and finish (matte or glossy) of the desired print.

Painting Media

Egg tempera is a medium that demands precise drawing and careful preparation before undertaking the actual painting, and the utmost discipline in its manipulation. Egg tempera consists of powdered pigment mixed with egg yolk, and diluted to a thin consistency. Although transparent and delicate, egg tempera is as durable and sturdy as oil, and not given to darkening or yellowing with age. Its demands may be rigorous but the rewards in clarity, charm, and permanence are well worth every task.

Opaque watercolor, sometimes called gouache, or tempera, is so versatile and amenable that, even on short acquaintance, there's hardly anything it won't do for you. As the name suggests, it's water-soluble and paintings should be framed under glass, like transparent watercolors.

Transparent watercolor is a medium that produces most exciting effects. To my mind, watercolorists are clearly divided into two main groups: There are those who wet the paper and then, in a frenzy of inspiration, attack it with volleys of masterful strokes, and spatterings and blobs of color that magically turn into the most spontaneous pictorial idioms. It's a matter of chance when anything is done with such verve and spirit, but the results are worth the risk—a painting so pulsating and unique that even the same artist couldn't possibly repeat. Then there are those artists who would rather use watercolor in a more methodical manner, working on dry paper, with layer after layer of flat and graded washes, done on a carefully transferred line drawing.

Oil, a medium with many virtues, is a favorite among both

embryonic and full-fledged artists. Oil has a certain sensuous quality that is downright irresistible. It can be applied in so many different ways, either directly—reveling in the brushwork — or in thin layers over an underpainting —glazing and scumbling, reaching for form, color, and texture. The student's chief attraction to oil paint is the medium's slow drying time which allows easy blending; other media require more training and dexterity. Another characteristic of oil is that it calls for mostly bristle brushes as opposed to the sables used for the water-based media. And although canvas is the conventional support for oil, you can also use wood, gesso, illustration board, cardboard, and even paper.

Acrylic is the newest of the pigments and has become so immensely popular that it threatens to depose the others. Acrylic can be diluted with water or thinned with polymer medium, but its chemistry is such that it becomes waterproof once it sets. Since it's as quick-drying as opaque watercolor tempera, any soft blending must be done quickly wet-into-wet or by drybrushing. I'm tempted to call acrylic the great impersonator because it can assume all the characteristics of watercolor, tempera, or oil. When diluted to a watery consistency, it takes an educated eye to detect the difference between it and transparent watercolor; it's also difficult to distinguish acrylic from egg tempera, when thinned to a middle consistency, and it's just as baffling to differentiate acrylic from oil paint when used on canvas, in body color, impastos, and glazes. A tremendous advantage to using acrylic in the oil manner is that it lets the artist proceed, without the long drying periods that oil requires between one stage and another. I use acrylic mostly as tempera on illustration or matboard, and thinned only with water.

Casein is another versatile medium that is water soluble, although its chemistry includes oil. It preceded for centuries the discovery of oil paint. However, when oil paint came along (perfected, it is claimed, by the Van Eycks), the older medium was shelved in favor of the new, more tractable paint, for rendering the meticulous detail and gemlike color that was the hallmark of the Flemish school. Casein has had a revival lately, probably because it dries quickly, and the artist can proceed with his work.

Brushes

Painting in small dimensions as I do, my brushes are correspondingly in the lower numbers. My biggest flat

bristle is a No. 12, my largest flat sable a No. 20, and my largest watercolor brush a No. 9. From these numbers, they range down to 00 in the pointed sables, and to No. 2 in the bright bristles. Sooner or later I get to use them all, but because my favorite media are egg tempera, opaque watercolor, and acrylic, and because I prefer to work in the smaller dimensions, my workhorses turn out to be Nos. 1, 3, 5, and 7 pointed watercolor brushes by Winsor & Newton, Delta, or Simmons. I suggest that you, too, buy the best, so as never to be hampered by inferior tools. Be frugal with paints if you wish, but never skimp on brushes. Take good care of them; swish them thoroughly in the water jar as you work, and wash them clean after each painting session. And remember that with brushes, as with shoes, the more you have, the longer they last. The brushes I use are shown opposite.

Ink

Drawing ink is a medium that requires a highly detailed drawing, because like watercolor, it allows no fumbling in the painting stages. There are as many techniques in ink as there are artists, but the results compatible with my mode of expression are obtained through superimposed washes or glazes. That is, I do the underpainting (if I may stretch the term) in black line and/or tone, and then glaze color over the black-line-and-white-paper foundation. Inks are convenient to set up, easy to handle, quick in execution, rich and luminous in color, equally appropriate for the most meticulous detail or the broadest suggestion, and they can be blended wet-into-wet or drybrushed. They have only one flaw: some of the colors are fugitive (that is, not lightfast). However, you can easily prevent the fading of any color by coating the finished painting with a mixture of equal proportions of Damar varnish and spirits of turpentine.

Dry Media

Pencils, pastels, and charcoal comprise the dry media used in this book, and their supports can range from the most transparent tracing paper to double-thick boards. Even though most artists gravitate toward oil, watercolor, and acrylic, remember that outstanding work can be done in any medium—including pencil. Actually the pencil is one of the most indispensable tools of an artist, and were it not for our familiarity with pencil since grammar school, it

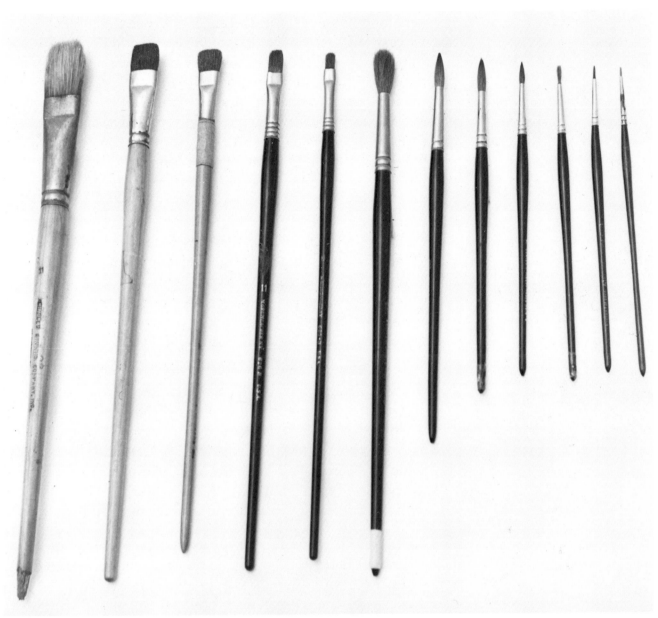

Since I rarely paint on a surface larger than 40" × 60" (101.6 cm × 152.4 cm), my brushes are correspondingly small. Here you see (left to right): Simmons flat bristle No. 12 and flat sables Nos. 20 and 14; Grumbacher flat sables Nos. 8 and 4; and Winsor & Newton pointed sable watercolor brushes Nos. 10, 8, 7, 5, 3, 1, and 0.

would be held in much higher esteem. I'd be at a loss without the "office" pencil (No. 2) for sketching and for drawing. Other pencils I commit to hard labor are the Draughting No. 314, General's sketching pencils 4B and 6B, the Stabilo black and white pencils (which mark on any surface, including acetate), and a hard 9H for most of my tracing. Long ago, in my youth, when I was investigating all media, I tried pastels but gave them up because of their fragility and because they wouldn't give me the meticulous detail I've always pursued. Today I sometimes do large drawings with Nupastels since their sharp corners allow me to draw thin lines; these in combination with charcoal, Conté pencils, and pastel pencils, can meet the most exacting detail.

Painting Surfaces

The traditional surfaces are illustration board for gouache, canvas for oil, and paper for watercolor. My favorite surface for all these media is illustration board, with small concessions now and then to the other two. I like boards because they give me any surface I want. I can take a large piece and expand the composition I'd originally planned, or crop it to smaller dimensions by simply trimming it with a matknife. I can readily get smooth (hot-pressed), medium (cold-pressed), or rough surfaces on a rigid support, allowing the heaviest impasto without danger of the medium cracking and chipping as is possible on more resilient ground. Illustration boards come in a single thickness of 1/16" (1.6 mm.) and in a double thickness of 1/10" (2.5 mm.); I use the former for small paintings and the latter for larger ones. It is also available in thinner or thicker backing boards referred to as lightweight and extra heavyweight, respectively. The surface I use the most is the cold-pressed, and my favorite brands are Bainbridge, Superior, and Crescent.

Another support that I use quite often for both dry and liquid media is matboard—in colors, as well as in whites and grays. If you prefer canvas, remember it can be obtained by the yard (in cotton or linen), or already stretched and trimmed to various sizes. There's also cotton canvas mounted on boards, and pads of canvas-textured paper. I've had difficulty finding gesso panels (Masonite coated on both sides for oil, egg tempera, casein, and opaque watercolor) in local shops, but they can be ordered from Sam Flax, Inc., in New York. Watercolor paper comes in loose sheets, pads, and blocks. There are so many brands and so

many surfaces and weights, that I suggest you consult an art supply store catalog for their description, or inquire at a painting supplies shop. Bainbridge matboard, single and double-thick, in colors and gray or white, is my favorite for painting, drawing, or matting.

Palettes

The best palette for mixing and thinning the water-soluble media is a butcher's tray. This, and china saucer nests and slant-and-well palettes shown in this photo, are all you need to hold your colors. If you paint in oils, then I suggest a disposable paper palette—it's so convenient to just tear off the top sheet and have a fresh, new palette.

Transferring Instruments

Capturing a sitter's likeness presents no problem to many artists, but for those who find it troublesome, there's hardly a better way than photographing the subject and

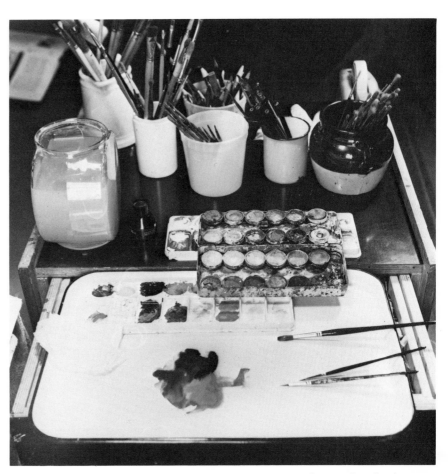

Here's a closeup of my painting equipment: taboret, butcher's tray, slant-and-well palettes, Marabu watercolor box, brushes and a bottle of water to rinse them in.

then slipping the print into the opaque projector. There will always be modifications to make in the drawing to emphasize the desirable or to subdue the objectionable. But these are minor adjustments that shouldn't affect the correct relationship of features captured for you by the camera and enlarged by the projector. Many portrait painters use this approach, supplemented by color sketches done directly from life.

The camera lucida (or "lucy") is a more compact instrument than the projector. It can duplicate, enlarge, or reduce any copy, and even three-dimensional objects, and has the added advantage that it requires no darkroom. While the projector is focused by adjusting the lens, the lucy's image is sharpened by using different lenses to suit whatever distance is required to enlarge or to reduce. It needs a bit of practice to operate, but it's really only a matter of keeping one eye on the lens that projects the image onto the drawing surface, and the other eye on the pencil point to guide it over the image. The camera lucida can also be ordered from Sam Flax, Inc.

The pantograph, like the lucy, can duplicate size, reduce, or enlarge, but it doesn't transfer three-dimensional objects. Pantographs are manufactured in wood or metal, or combinations of both, and run as a rule from 14 to 26 ratios to enlarge or reduce. It's a very simple device consisting of four bars. Picture two XX's joined together, with scale markings where the "strokes" cross. This may sound a bit bewildering, but the manufacturers have seen to it that full instructions and explanations are enclosed with each instrument; a pantograph can be purchased from Sam Flax, Inc., for as little as $5.00.

Magni-Focuser

The trade name for what I've come to call "peepers" is Magni-Focuser, shown in the photo opposite. It's a simple device adjustable to one's head like a visor, but with two lenses on the "shade" that magnify tiny detail—either to "read" it on a photo or to execute it on a painting. I've mentioned that I'd try anything to make the job easier, and this is one of the gadgets that help prevent eye strain. Another one is a hand-held magnifying glass, but I prefer the peepers because it leaves me with both hands free to work. There are also magnifying lenses which are set on a flexible stand, but I can't use them because of the steep slope of my drawing table.

Pana-Vue

This is simply an electrically lighted box that enlarges a 35 mm. slide (slipped into the back) to 2½″ × 2½″. If this enlargement does not clarify some tiny detail, I then put on my peepers for further magnification.

I prefer the "peepers" to a magnifying glass because it allows me to use both my hands.

Shooting Source Material

When going out to photograph subjects for painting, make a resolution to record only the things that you would otherwise draw or sketch. This will prevent you from shooting indiscriminately everything in sight just because it's so easy to press a button. However, when you find something you really like, it's better to photograph more than you might need than to regret not shooting enough—especially when the subject is far away and not easily accessible to you. Another reason for taking several shots of the same subject is to get close enough for details. Try photographing the subject in sections; you could rest the camera on a tripod or on a sketching easel to help keep the same eye level. If the ground is very uneven, don't worry too much about it—whatever slight variations occur in your photos are of no great importance. When shooting buildings, it's better to move and face squarely one section at a time, than to pivot and shoot from a fixed position, since this tends to distort the subject. (A panoramic view can, of course, be panned from one spot.)

Once you begin to observe, you may find that there are things right in your own backyard that you've never noticed. Look for interesting shapes and textures, and if the color scheme is also interesting, then consider it a bonus. Quite often the color is "off" or has to be changed to fit a particular scheme—but this can easily be done later while painting. If a good camera poses no problems for you, then by all means use it for better results. But if you're like me, then keep the Instamatic always ready and just snap away. When going on a holiday keep an eye on possible subject matter even from the road. Look around when you stop to "take five." Walk around the inn or the road stand—some good subjects are usually behind them and out of sight. Let somebody else drive through beautiful countryside so you can really watch for source material. Upon reaching your destination, continue your search for the things *you* find appealing. Don't let rain or fog or wind deter you—they can produce some marvelous effects.

When you find an interesting subject (left), look for the best view of it (right).

Don't settle for just a glimpse of your subject (left); move about to get definite shapes, and wait for the right light if you can (right).

Get as close as possible to see details (left); it's easy to remember (and not necessary to record) that the house had a gable (right).

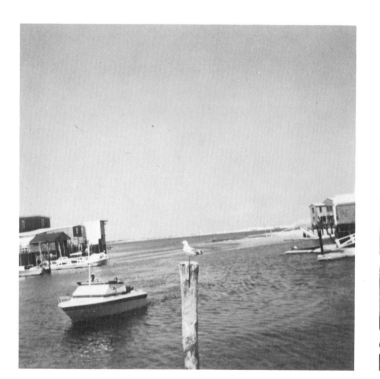
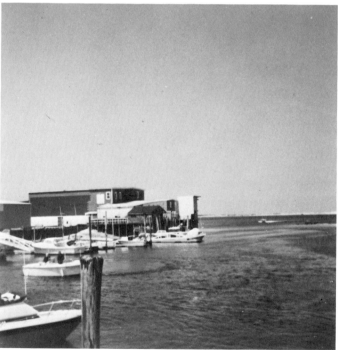

Don't try to shoot too many elements at once (left); better to take individual shots and then tape them together (right).

Concentrate on recording transitory weather conditions (left); an interior can always be done from the real (right).

Avoid the bizarre (left), even when it happens in nature; concentrate instead on the beauty which abounds in nature (right).

Forget the typical "snapshot of Dad at the beach" approach (left), and look instead for elements that could lead to a painting (right).

If the figure is what you're after (left), then don't camouflage it (right).

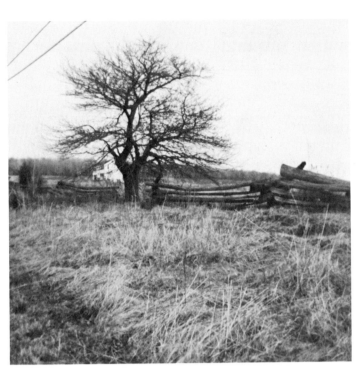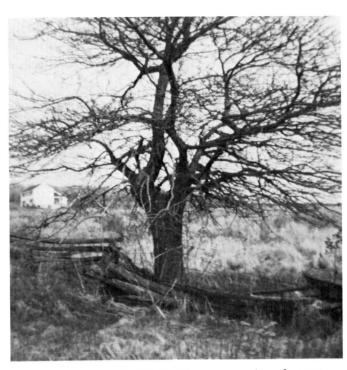

If the ground itself is interesting, shoot it (left); if an interesting element is nearby, walk up to it and get that too (right).

When you find an unsual subject (left), get up close to see its real character (right).

Enlarging the Photograph

It's obvious that the average snapshot must be enlarged to adequate painting proportions. The increase in size depends upon the individual artist; your preference may be anything from a diminutive canvas to a heroic scale support that can cover a wall. Of course, size is relative; what is large to me may be small to you. So, why don't you explore various dimensions and select those that enable you to do your best work. In the projects ahead, I'll simply explain and describe the various methods of enlarging the photos, and leave it to you to choose the degree of enlargement.

Some considerations you might keep in mind concerning size are: (a) There are exhibitions that won't allow anything over 60 inches in width. (b) It's wise to suit the medium to the size; one can easily cover large canvases when using oil color but it would take an eternity to paint a large picture in egg tempera. (c) When shipping large paintings for exhibition in another city the cost can be considerable. (d) Your painting corner may not permit you to work larger than an 11″ × 14″ (27.9 cm × 35.5 cm); if you hanker for larger sizes then you must find quarters that allow you to do so.

Squaring-Up

The squaring-up method of enlarging a photograph — drawing a grid over the photo, and reproducing, on another sheet of paper and in larger scale, exactly what's contained in each square—is the most popular because it's so easy. When the detail is too profuse in any particular square, you just subdivide that square into still smaller sections. This facilitates your checking the relationships of the subject matter to the vertical, horizontal, or diagonal lines of the grid.

Another reason for the popularity of the squaring-up method is that no special apparatus need be employed, and therefore no expenditure need be incurred. The only equipment you need are a ruler and a watercolor brush No. 1. To construct the grid, you should master the "ruling method" (demonstrated in the photo below). I'll describe it as clearly as possible. I hold the bottom end of an 18″ (45.7 cm) ruler vertically in my left hand, and rest both it and the ruler's top end on the drawing board. Then, after charging a watercolor brush with paint and working it to a point on the palette, I hold it like a pencil, place the tip of my middle finger on the ruler's metal-tipped edge, and slide my hand down, resting it on the board all the while to maintain the same pressure so the line won't vary in weight.

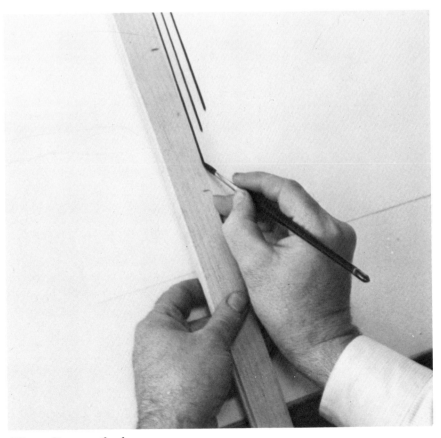

The ruling method.

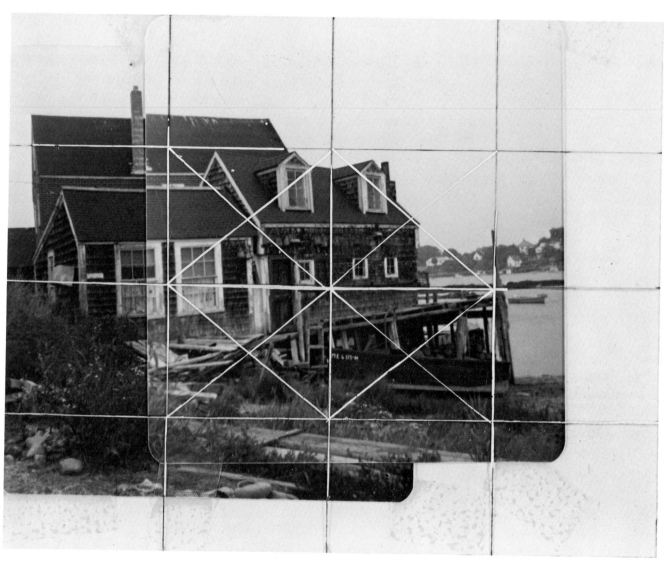

1. Drawing the Grid. Here are two photos snapped in Maine, taped together, with a piece of acetate on top so I can do the grid without defacing them. To draw the grid, I use the ruling method and a Stabilo pencil. Where the black line doesn't show over the dark areas of the photo, I switch to white opaque watercolor and a No. 1 watercolor brush. The grid here measures 4⅛″ × 5⅜″ (10.5 cm × 13.5 cm) and I plan to enlarge it in length to 18″. First I establish an appropriate area for the subject matter. Notice that my grid goes beyond the edge of the photo at the bottom and on the right for better balance and to give the subject more distance. Then I mark the center of the rectangle and strike a vertical and a horizontal line, forming a cross in the middle of the panel. Next I subdivide these four rectangles into still smaller ones, and where there's the most detail, I do the diagonals you see. When the grid is done, the photo is ready to be enlarged to whatever dimensions desired. Some artists work big, while others prefer smaller supports.

A

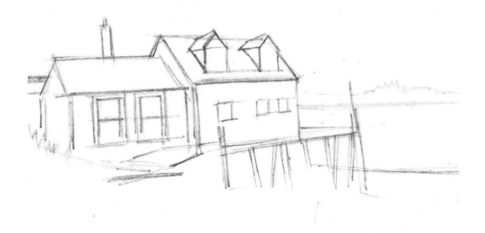

B

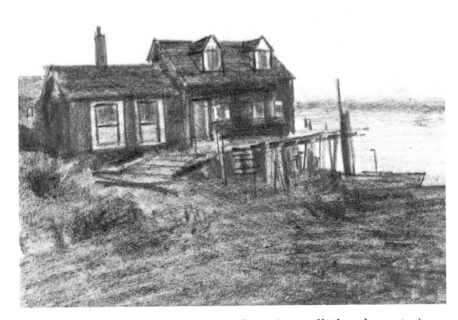

2. Selecting the Main Elements. Sometimes all the elements in a photo can be used—with modifications—but usually there's something to delete or add for a better composition or to stress the character of the subject. Before enlarging, I decide to work out a tonal scheme to see if the changes I planned will work out. I place tracing paper over the photo and lightly indicate the outline of the main elements (A). Notice I've discarded the rear building to make the roof silhouette of my motif stand clearly against the sky, retained one of the chimneys and removed another, and shifted the boat to make it "read." After removing the tracing paper from the photo, I apply the tones (B). At this point I don't know if I'll include the lobster markers—they've become such a cliché, but if I need them I'll use them.

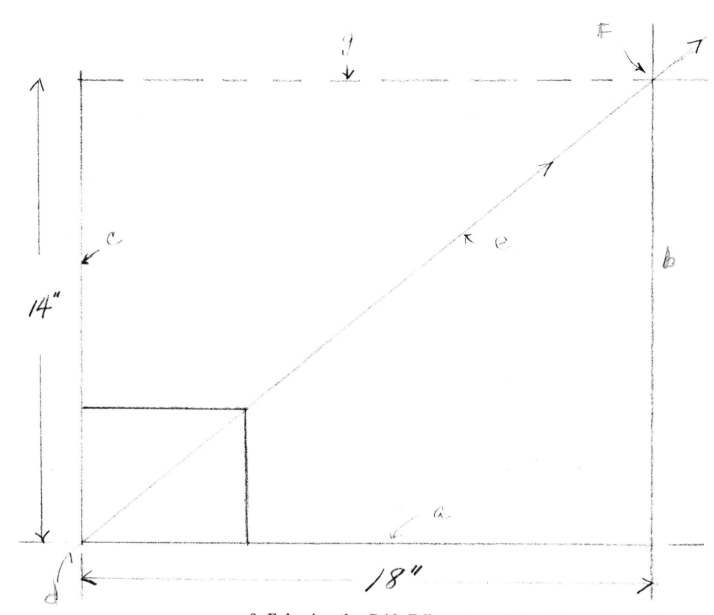

3. Enlarging the Grid. Follow me carefully. Using a No. 2 office pencil on a sheet of tracing paper 18¾″ × 24″ (48.2 cm × 60 cm), I draw an 18″ (45.7 cm) horizontal line (a) for the bottom of the grid and two perpendicular lines (b and c) which are the right and left boundaries of the grid. From point d I extend a diagonal line e until it intersects line b at point f; this point establishes the height of the grid —14″ (35.6 cm). From f, I run line g to the left until it meets line c. Now I subdivide this larger grid the same way I did the smaller one, beginning with the center vertical and horizontal lines forming a cross.

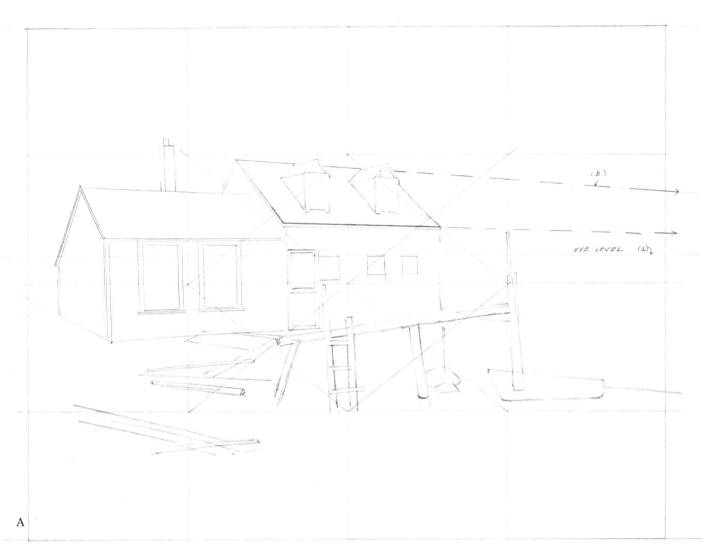

A

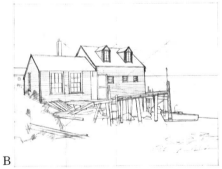

B

4. The Working Drawing. Use a sheet of transparent tracing paper for your pencil drawing so you can slip the grid underneath and still see it clearly. Now the first thing I do is to look for the eye level in the photo. Holding a ruler horizontally across the photo, I move it up and down to find the elements that align themselves along the ruler's edge. If your snapshot deals with rickety or leaning buildings, then search for the horizon, which can be ascertained even when camouflaged by trees or other obstructions. Here I estimate the eye level to be at the top of the small windows and indicate it in my preliminary drawing (A) with line a. To find the vanishing point on the right, I extend the slanting top edge of the roof (b), until it intersects the eye level line (a) —outside the photo. At the point of intersection, I put a pushpin and, by resting the ruler against it, I can find all the lines that converge on this vanishing point. For the left vanishing point, I extend one of the shingle lines on the left wall of the front building. Now, with the eye level and the two vanishing points established, I can correctly place any element I want in the picture. If the grid lines over the photo obscure a small detail, I lift the acetate and scrutinize it with my peepers. Notice I begin with the contours of the biggest shapes, and then, just as when sketching from nature, I introduce some smaller details within them. However, I only draw in those details I consider essential; the smallest, such as shingles, blades of grass, pebbles, etc., will be rendered right on the painting. After I've completed my drawing (B), I trace it to a 15″ × 20″ (38.1 cm × 50.8 cm) piece of Bainbridge No. 80 illustration board.

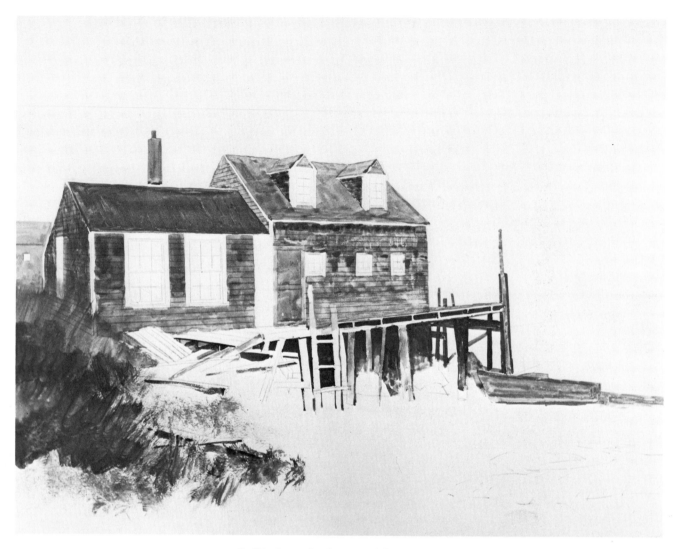

5. Underpainting and Painting. I begin painting with burnt sienna, yellow ochre, ultramarine blue, black, and white opaque watercolor. I use the point and the side of a No. 5 Winsor & Newton watercolor brush with pigment so thin that the traced pencil lines on the shingled walls can still be clearly seen. First I give the sky a thin coat of white tempered with yellow ochre, then I paint in the foreground, completing the dark portion of the picture. I move over to the windows, still working thinly and broadly, without concern for any detail. The idea is to cover the entire board with the dark and light shapes as quickly as possible.

Now I'm ready to begin rendering from the back forward. I do the sky first, adding a touch of ultramarine blue to the white and yellow ochre I used in the underpainting. Then, I paint the water in the same colors, only slightly cooler, checking the photo for color suggestions. I move on to the small building on the left edge of the picture, working these elements slightly into those in front. With opaque watercolor, I can easily regain the contours I've overlapped.

Opaque Projector

I'd be willing to wager that, among artists, the favorite way of enlarging a photo or a drawing is the opaque projector. At any rate, this is the apparatus most commonly found in commercial studios, with a camera lucida running a close second. The projector is so simple to use that if a drawing falls short of expectations, another photo can be "blown up" in a matter of minutes. But don't just enlarge the photo as is—especially one taken by nonprofessionals like you and me. There will usually be things to add, modify or delete.

I wish you were here in the studio so I could show you first-hand just how easy it is to get a drawing from a projector's image. However—since you're not here—refer to the illustration below to see how I set up the projector to transfer a photograph.

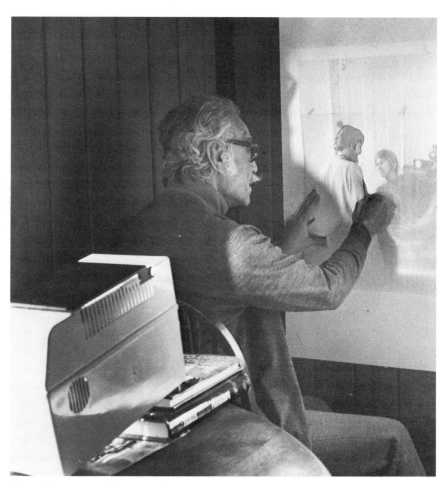

Transferring a photo with an opaque projector.

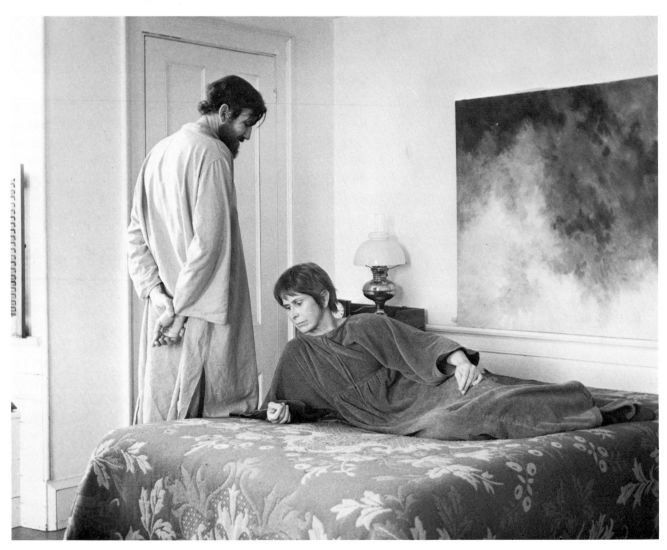

1. Enlarging the Photograph. When I saw this photo I felt there was something so warm and tender in the couple's attitude that I couldn't wait to use it in this project. As always, there are things to correct, but the possibilities outweigh the imperfections. Besides if it doesn't come off well, I'll simply select another photo and straightaway have another go at it, relying on the efficiency of the projector.

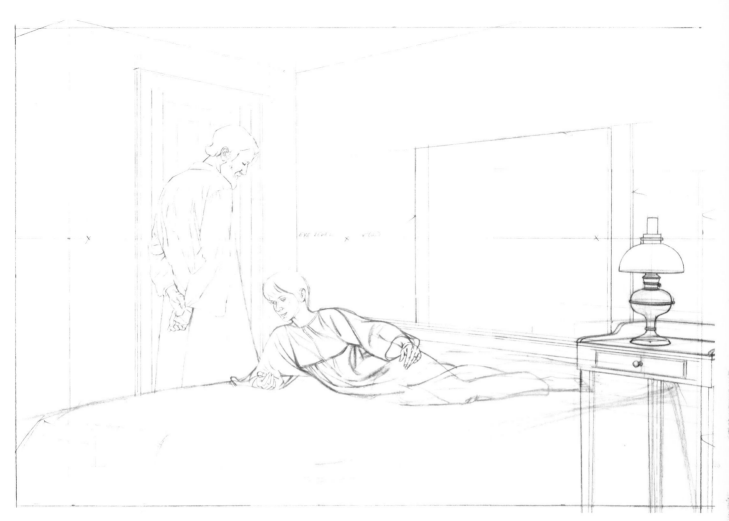

2. The Drawing. After using the projector to enlarge the 8″ × 10″ (20.3 cm × 25.4 cm) photo to a 15″ × 23″ (38.1 cm × 58.4 cm) drawing, I move this enlargement to my drawing board, and work, once again, in the fully lit studio. I find the eye level (line a) by extending the top and bottom lines of the painting on the wall until they converge at a vanishing point—outside the boundaries of the drawing. I'll list the changes I make in my drawing, so you can easily check them with the photo: shift the night table (and relate it to eye level) so lamp won't appear to rest on the woman's shoulder; move door to avoid bad tangent with the man's left arm; lengthen her figure a bit to make it more graceful; make bed longer because it looked short in relation to figures; remove awkward fold from her left shoulder, and change the angle of his shirt for better unity.

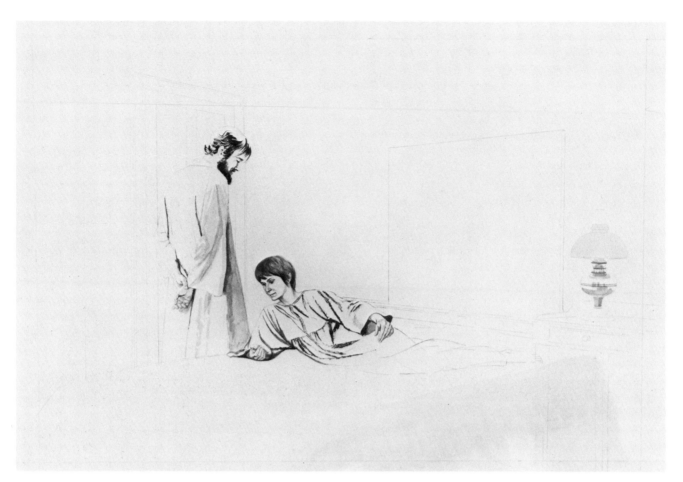

3. Beginning to Render. I've traced the drawing onto a piece of Bainbridge illustration board No. 80, and begin to apply both line and tone with Nos. 1 and 3 watercolor brushes, using India ink straight from the bottle for the darks, and diluted with water on the butcher's tray for the grays. Another approach would be to establish all the blacks first, and then, adding more and more water to the ink, to indicate the middle-tone and the light grays, leaving the paper itself for the whites. I've set down some darks full strength so as to better judge the value of the grays that follow. I work all over the picture, being careful that a tone is somewhat lighter than required, because it's easy to darken it with another wash, but quite a tough job to make it lighter.

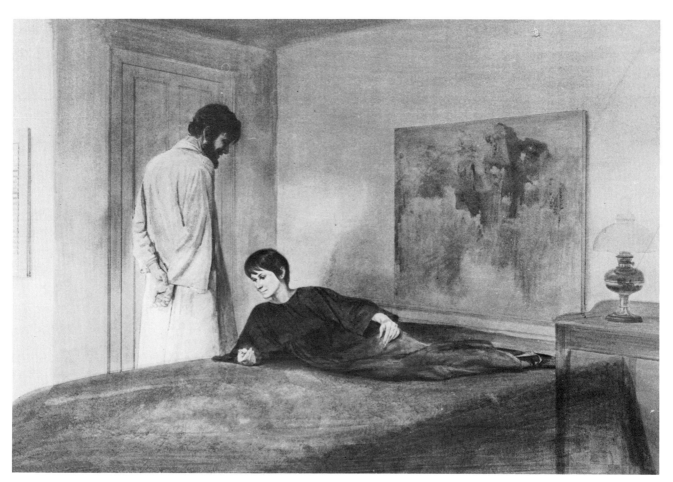

4. The Tonal Scheme Established. I continue using Nos. 14 and 20 flat sable brushes to apply the washes in the larger areas; their long handles give me a chance to work at arm's length and see clearly the overall design of the picture. If, as you work on your own painting, you find that a wash could be more easily manipulated by turning the picture upside down, don't hesitate to do so. Notice how I'm pulling the picture together by deepening some tones and lightening others to get rid of the spotty look of the photo, and how without the black angle of the painting on the wall, the eye goes directly to the figures.

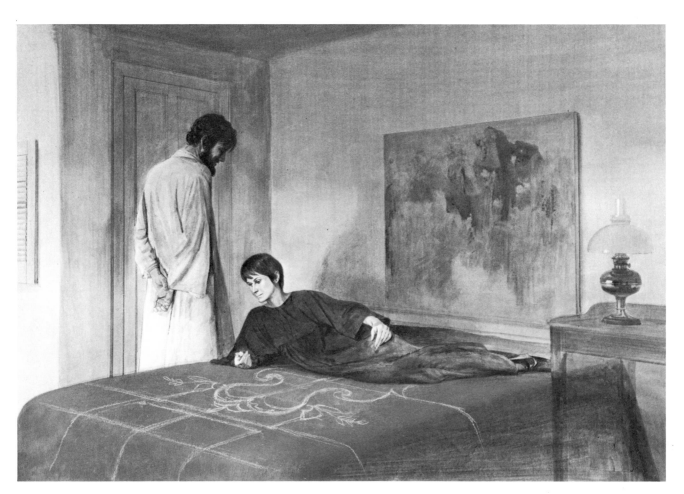

5. Final Details. I won't finish the painting since the purpose here is only to demonstrate the ease and expediency of a projector. If the picture is to remain in black and white (you could switch to opaque watercolor for the last touches), care must be taken to add yellow ochre and/or raw umber to the grays to give them the warmth of the India ink. Here, I add highlights to the lamp with opaque white and start the pattern on the bedspread with a white Conté pencil. I could switch to egg tempera in a color scheme that would suit this mood of the subject, and use the ink rendering only as the underpainting, as the Old Masters did.

PROJECT 3
Camera Lucida

I've said it's my belief the "lucy" is second in popularity only to the opaque projector among professional artists. This is understandable, since the lucy requires no darkroom, is easily portable, and far cheaper than the better kind of opaque projectors. I must admit that, personally, I preferred the latter when I was engaged in commercial work, probably because the projection room was so convenient—a place apart from the studio proper, kept in perpetual darkness and ready to be used, with no curtains to draw or anything to set up. There would be a "beaver board" wall where the artists could pushpin sheets of paper or illustration board, then slip the photo in the machine, and be ready for business in a matter of minutes. There are, however, artists who swear by the lucy and I mention it because—who knows—it may turn out to be *your* favorite!

For this project I'll use casein paint. Perhaps you're not familiar with casein, so I should caution you about rinsing the brushes during a painting session, and washing them thoroughly with Ivory soap and warm water before putting them away for the night. I tape a bar of Ivory on the butcher's tray so that when the brush begins to lose its snap, I just rub it gently on the soap before rinsing it and picking up another color.

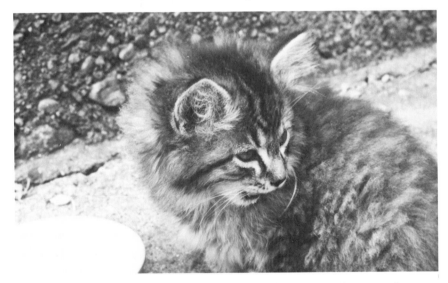

1. The Photograph. As I said before, the lucy can enlarge, reduce, or transfer in the same size anything placed before it — even three-dimensional objects. Which means that no time need be wasted or money spent in photographing the object, as the projector and the pantograph require. A shell, a flower, a pine cone and things of that sort can be transferred from the real, but since a kitten couldn't be pinned to the wall, I'm using this photograph taken by a friend. At first I hesitated making it do for this project because it doesn't show the entire creature, but realizing that the rest can be so easily added, and its appealing gesture probably missed by attempting another shot, I decided to use it.

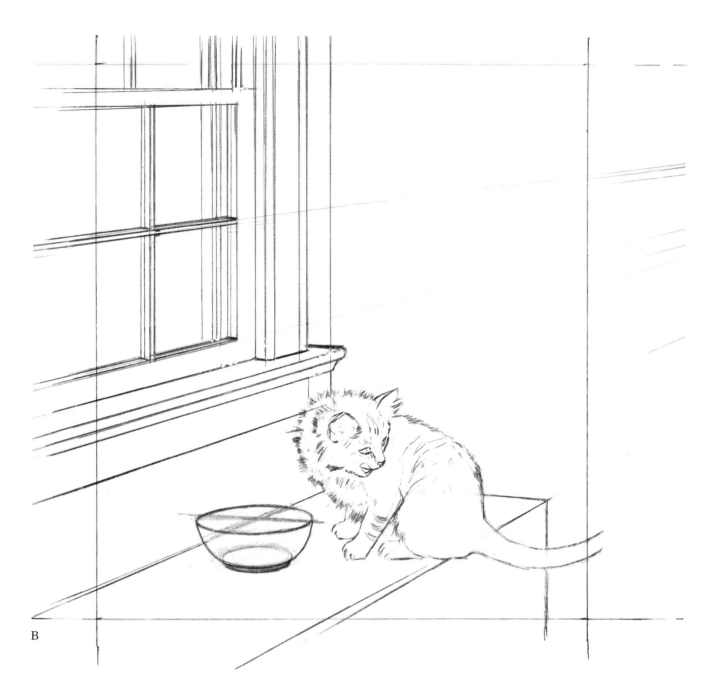

B

A

2. The Line Drawing. Using an office pencil on a 13¾″ × 16½″(35 cm × 42 cm) sheet of tracing paper, I did a quick basic sketch of the kitten (A), and then developed a setting around him (B). If you look at the original photo, you'll notice that the lighting is from upper left. So, since I brought Napoleon—the cat—indoors as I did, a window in the upper left part of the picture is in order. I've also rearranged his paws and changed the ellipse on the bowl to make everything conform to the lower eye level, which is the result of my raising him off the ground and placing him on a bench. There's only one thing that bothers me now: that awful triangle formed by the corner of the bench and his tail. I must do something about the triangle eventually.

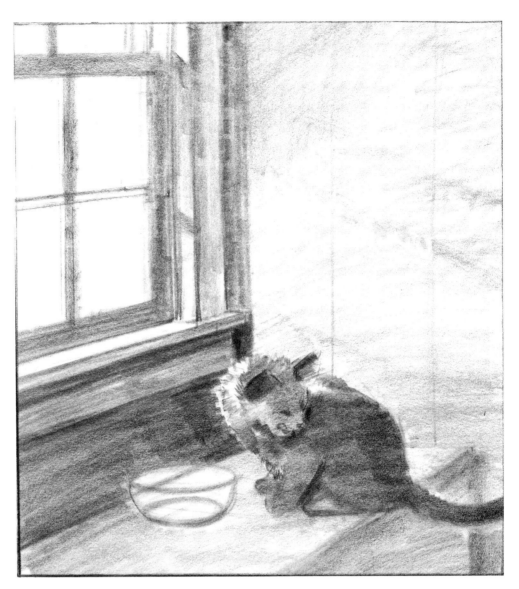

3. The Tonal Sketch. Since the drawing is so different from the photo, I must now develop a tonal scheme for the new setting. Not difficult to do, really, if I study the lights and shadows of a window in my studio. I'll do the shadow under Napoleon from imagination, but I've placed a bowl by the window to see how the "available light" affects it. (This is a term used by photographers when referring to the light that illuminates a room without benefit of artificial lighting.) At this moment I'm debating whether I should let the sun come in, or keep a diffused light without the harshness of cast shadows. I know there's got to be a bit of landscape, or cityscape, seen through the window but I still don't know which. One thing for sure though: whatever I decide upon must relate properly to the elements I've already established. That triangle is still there but maybe I can subdue it with tonal manipulations. For this tonal sketch, I use a No. 314 Draughting pencil on another sheet of tracing paper, taped over the line drawing done in Step 2.

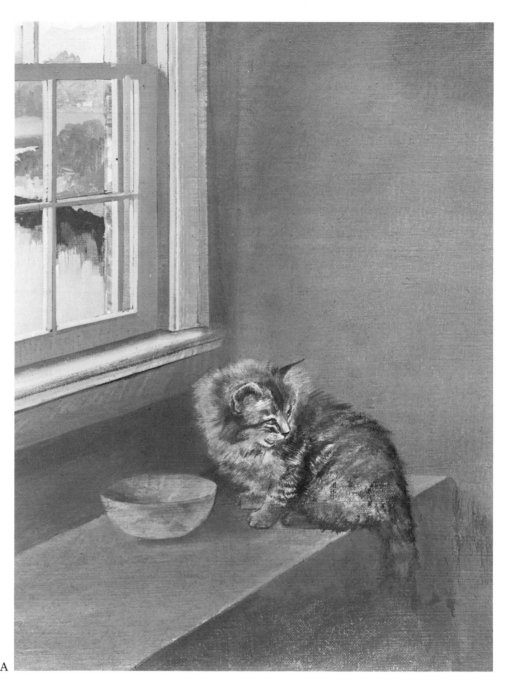

A

4. The Casein Underpainting. After I trace my drawing onto a canvas panel 16″ × 16″ (40.6 cm × 40.6 cm), I begin my casein underpainting (A). My palette in this case consists of thin solutions of Shiva casein colors: burnt umber, yellow ochre, Shiva green, ivory black, and titanium white. I use a Simmons No. 7 bristle flat for the large areas of the wall and the seat, and Nos. 3 and 5 watercolor brushes for the kitty, the window, and the landscape that I'm adapting from this photograph (B). I also give the entire surface a glaze of burnt umber and white to warm it up.

It's time to rearrange the tail, so employing my customary procedure, I tape a piece of acetate over the painting and change the tail so that it hangs straight down. Now its vertical movement echoes the vertical thrust of the window and helps unify the picture. However, if the tail hadn't looked better in this position, I would have simply washed if off the acetate and tried it again in another position. It goes without saying that I removed the acetate and painted the tail as you see it here.

B

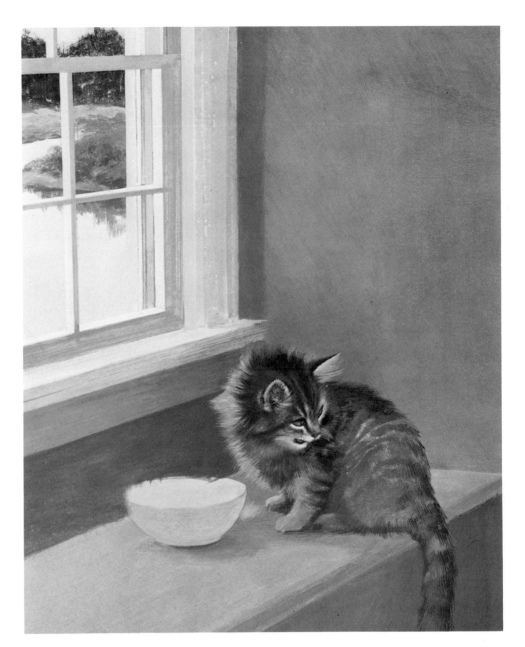

5. Developing the Painting. I've trimmed the picture to 12¾″ × 10½″ (32.5 cm × 26.5 cm), the dimensions that suit the composition best. I use only watercolor brushes and thin washes of the same colors as in Step 4, letting the value and color of each wash influence those that follow—sometimes blending wet-into-wet and sometimes drybrushing. I shape a No. 2 brush to a point on the butcher's tray to do the detail on the kitten's head. Even though the final rendering remains to be done, there's enough here to show you how it will look. The aim of this project is to acquaint you with the camera lucida, and if I've stirred your curiosity enough to try it, I've already accomplished my purpose.

PROJECT 4
Pantograph

This is the least expensive of the three mechanical devices used in transferring copy to a drawing surface. Inasmuch as everything concerning picture-making should be investigated, I hope you don't ignore the pantograph, even if you have to borrow or rent one. This holds true for the lucy and the projector—try them all, then acquire the one that best fits your needs.

I will do this project in Gamma grays, a set of opaque watercolors in a graduated tonal scale of gray values, numbered one through six, plus black and white. I need hardly mention that a painting in black and white lacks the appeal of color, but working with these grays is good experience for you in judging relationships and in handling the pigment. Do try them to train both your eye and your hand. If the painting turns out to your satisfaction, it can be isolated with a coat of varnish and finished in oil paints, or sprayed with fixitive and used as an underpainting.

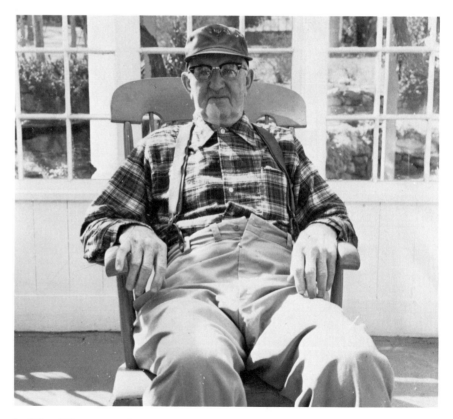

1. The Photograph. Every time I come to Maine for subject matter, I'm captivated by both the landscape and the people. There was no question when I met my friend Joseph Houston (who insists on pronouncing it *Hooston*, and if Texans and New Yorkers choose to pronounce it otherwise, that's their affair), that I just had to paint him. I posed him facing the camera squarely, to convey his unflinching and straightforward way ... a man evenly balanced and firmly planted ... a stalwart figure ... a monolith upon which many a storm has spent itself.... I list these disconnected thoughts because I'd like you to examine your own subject just as closely before painting, whether it's an adolescent, a clown, a priest, or a chorus girl.

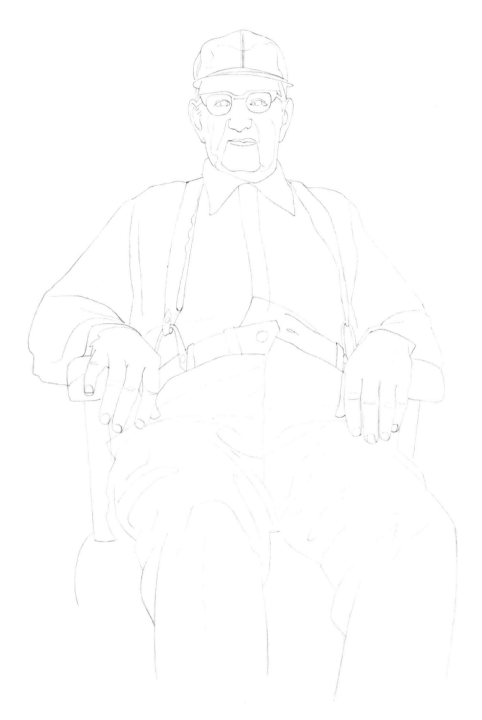

2. The Enlarged Drawing. There are times when copy has to be reduced, but as a rule, the small photograph has to be enlarged to painting size. This is the line drawing on a sheet of tracing paper 17½″ × 17½″ (44.5 cm × 44.5 cm), enlarged from an 8″ × 8″ (20.3 cm × 20.3 cm) photo. I've eliminated the back of the rocker because I want to silhouette the head against the sky. Everything is drawn in proportion to the copy, including the somewhat distorted hands which are too big —but that's the way I want them. Before proceeding, I set the pantograph to a smaller ratio to reduce the camera distortion in the leg area. Notice I've transferred only the essential shapes; later I can incorporate the smaller details and refinements straight from the photo, without the pantograph. Of course, there's no reason why you can't get every bit of detail with the instrument itself.

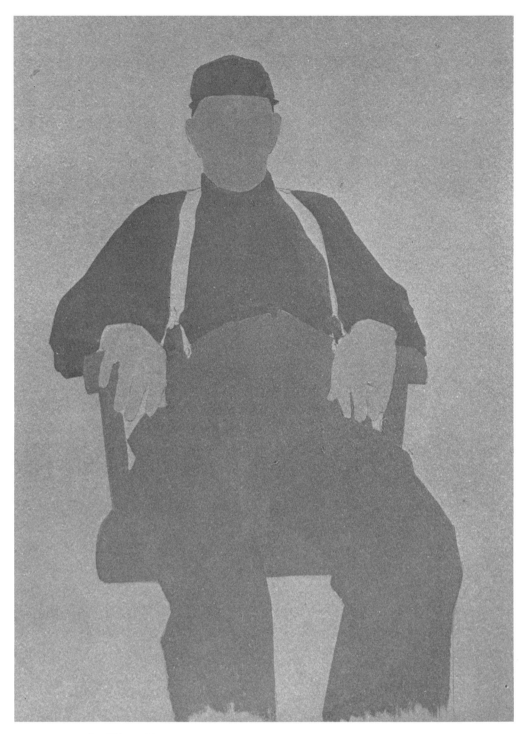

3. Flat Shapes Painted. Here I choose a gray matboard (also 17½" × 17½") because it's the right value to balance subsequent darker tones, and to get rid of the light "holes" that destroy the solidity of the figure in the photograph. I trace only the contour of the big shape. Then, using Gamma grays, thinly diluted, I paint the shirt and the trousers with a No. 14 flat sable brush. I switch to a No. 5 watercolor brush to do the head, the hands, and the seat. The suspenders, which are left untouched, appear lighter than the background because of the dark shirt behind them.

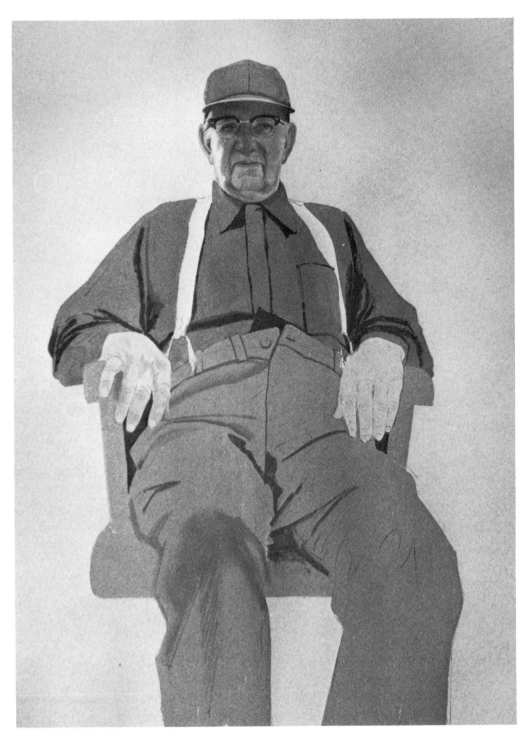

4. Beginning to Render. Again using the pantograph, I trace the features on the face and the folds on the clothing, and begin rendering with pointed sable brushes Nos. 1, 3, and 5. At this point I'm beginning to get the bulk of the figure and the solid silhouette I had visualized from the start. I've squeezed dabs of pigment in a slant-and-well palette and thinned them with water because the paint is very difficult to handle as it comes from the tube. I'll further dilute it on the butcher's tray as the need arises. I'm drybrushing the blended edges and constantly consulting the photo for the smaller details I didn't transfer with the pantograph. When I rest my hand on the board to do the tiny details on the face, I slip a piece of paper under it to protect the areas already painted. So far I've used grays Nos. 2, 3, 4, and 5, plus black.

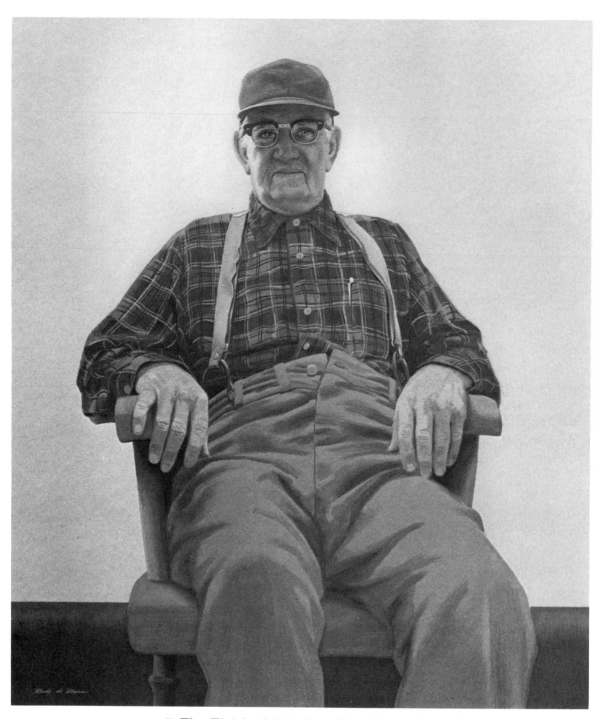

5. The Finished Painting. Now, I'm really underway, and from this stage forward, I can take any section and carry it to completion. I turn the rocker into a captain's chair, crop his legs, and add a dark band at the bottom so it serves as a base to the "monumental" figure I'm after. I use a light gray Nupastel around his head to strengthen this part of the silhouette. If later I decide it's not needed, I can easily remove it with a piece of kneaded eraser.

Placing a piece of tracing paper over the painting and checking the photo, I do the design on the shirt entirely by eye. First, I work out only the largest checks; later, on the painting itself, I add the smaller linear light and dark details. Always begin with the biggest shapes. Obviously, if the big shapes are correct, their subdivisions will also be in proportion, because it's easier to judge relationships as an area gets smaller. (This painting reproduced courtesy of Mr. Joseph Houston.)

PROJECT 5
Visual Approximation

Sometimes a painting or drawing begins with an artist's prevision—vague images floating through his mind; later he might consult nature for the elements he may need to secure drawing and color. Sometimes, instead, he might go to nature first, and then bend it to his imagery through sketches and studies. I've a notion it was while engaged in the latter approach that some artist conceived the idea to let the camera record in seconds what would normally take hours and several sketches to accomplish. However, there are a few disadvantages to using photos. One is that the stimulating influence of nature is forfeited; another is that color has to be developed away from the actual elements, and no camera can capture the subtleties of color perceived by the human eye. So, to develop your creative instincts while drawing or painting from photographs, I urge you to practice enlarging or reducing by eye—it's the next best thing to working directly from nature.

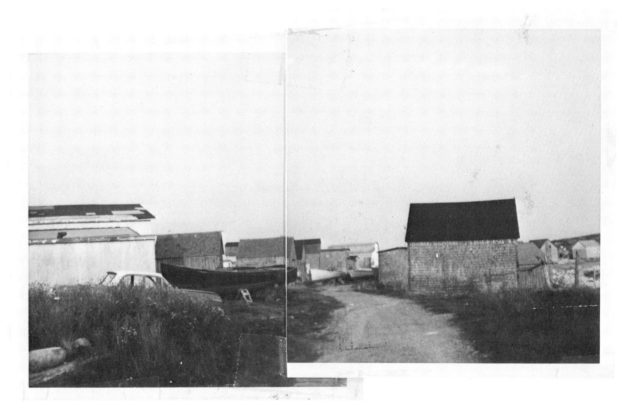

1. The Photograph. When I do a sketch on the spot, I know right then and there if it's worth keeping. When I take an Instamatic shot I have to wait a week or so (while it's developed) to see the result. Here are two snaps that I taped together. At the time I took these pictures, I thought of reorganizing the buildings to make the silhouette more interesting. I also considered adding to the foreground, which is rather empty in the photo; this is because I was standing very close to the buildings to get their details. In addition, I found the skyline boring. You might try taking notes with your snapshots: "Fishing shacks, Neil Harbor—skyline too even, more foreground needed." This way you can easily recall later whatever alterations you had in mind.

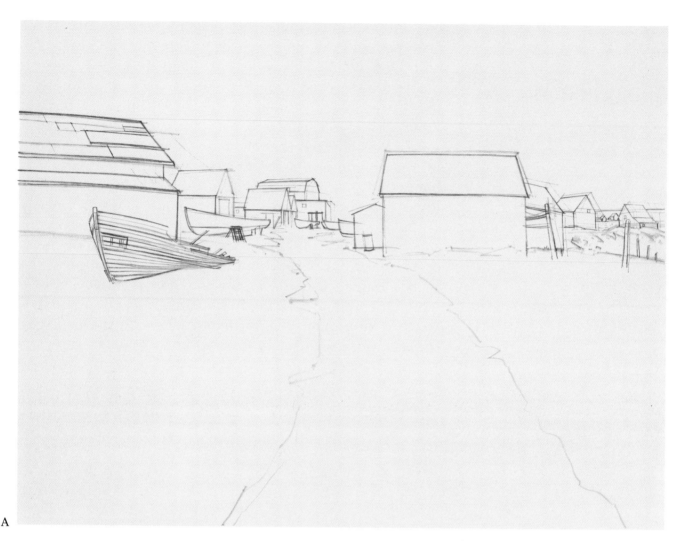

A

B

2. Preliminary Drawing. On my 19″ × 24″ (48.3 cm × 61 cm) No. 524 Aquabee tracing pad, I begin my first attempt to organize the shapes (A). My purpose is to make the shacks as interesting as possible in shape, size, and placement. I enlarge by eye, working from left to right. Using an office pencil, I indicate the size and position of the elements with a very light line. Note that I've lifted the motif to the upper part of the paper to improve the composition. When the light indication is done, I return to the left and begin stressing with the same pencil (by applying more pressure) those lines I want to retain. Compare this first drawing with the photo and I'm sure you'll agree that the disposition of the shapes is now far more interesting. I could have retained the car in the picture, but I felt that another boat would reinforce the seaside atmosphere. I consulted another photograph (B) for the shape of the boat.

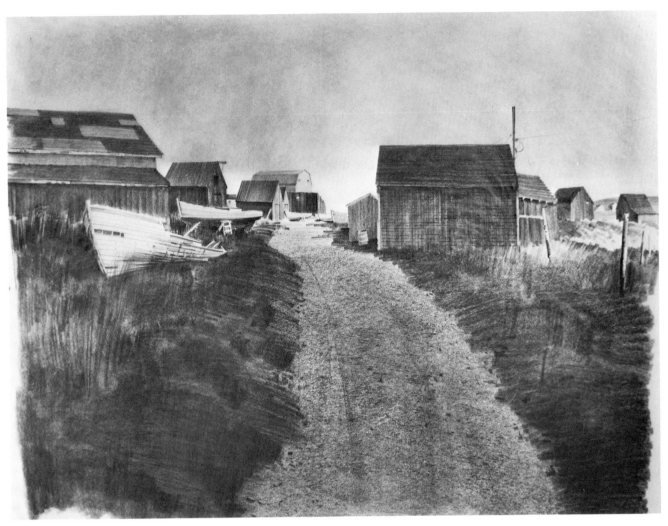

3. The Tonal Sketch. The application of tone immediately brings up the question: Am I to retain the lighting in the photo or shall I select a light source of my own? If you check the photo in Step 1, you'll notice that the lighting is rather confusing. There's a definite cast shadow on the second building from the left, indicating a light coming from upper left. But the barn near the center of the picture shows its lighter plane on the right, as does the little shack on the right edge of the photo. So, to play up whatever lights, grays, and darks I need without transgressing on a sense of rightness, I choose a gray day with diffused lighting. Even though there are no cast shadows anywhere, I consistently "force" the difference in value between the planes of the shacks to give them volume and solidity. As I work all over the drawing, I take care not to go all the way down to the blacks until I'm sure where these belong. I also keep an eye on the distribution of the textures and try to juxtapose a busy area against a calm one to avoid overtexturing the drawing. Note that I've retained the calm road between the two busy areas of grass, and a calm sky as a backdrop to the textures of the buildings.

Composing Your Picture

A drawing or a painting begins with a blank piece of paper or a bare canvas. Most of us face these pristine grounds with a preconceived idea of what we want to say visually and our first concern is the division of the area into shapes, forms, and textures to get the most forceful, rhythmic, and beautiful result possible. As Sir Joshua Reynolds expounded so lucidly: "Composition, which is the principal part of the invention of a painter, is by far the greatest difficulty to encounter. Every man that can paint at all can paint individual parts; but to keep these parts in due subordination as relative to a whole, requires a comprehensive view of the art that more strongly implies genius than perhaps any quality whatever." To put it in a nutshell: composition is the arrangement of *the parts* to create a *unified whole*.

The best way to begin a composition is by placing the bigger shapes first so that the smaller ones can be properly related to them. The picture area can be divided into as complex an arrangement of shapes, with as much detail as you wish; so long as they remain anchored to a distinctly organized pattern, the impression of unity will not be lost. It is by adding or removing an element, enlarging or reducing another, deepening or lightening a tone, and accentuating or subduing a texture, that the artist refines his composition and creates a cohesive statement.

PROJECT 6

Combining Several Photographs

Is there an artist that wouldn't be captivated by these forlorn and pathetic boats? I remember parking the car and getting all set to read the time away while my wife shopped for antiques. Then, checking the scene as I always do, no matter where I am, I spotted these creatures lying in a marsh. I instinctively grabbed my sketching materials, but then I remembered I was doing this book, so I put them back and picked up the Instamatic instead. I took several photographs, each giving me an intriguing and different view of the boats. Then I studied the photos and chose four that I thought would best lend themselves to an interesting composition.

As will often happen when composing a picture using elements from several photographs, I decided that one particular photo would work better if it were "flopped," or reversed. There are several ways to flop a photo: (1) place a sheet of tracing paper over the photo, draw the object, and then check the reverse side; (2) hold an Instamatic photo against a window pane and outline in pencil the main shapes on the back; (3) have a photostat made of the photo and ask the man to flop it; (4) place a photograph upside down under a mirror and then draw the reversed image. This last method is the one I will use.

Here you can see how I flop a photograph: Turn it upside down in front of a mirror and draw the reversed image.

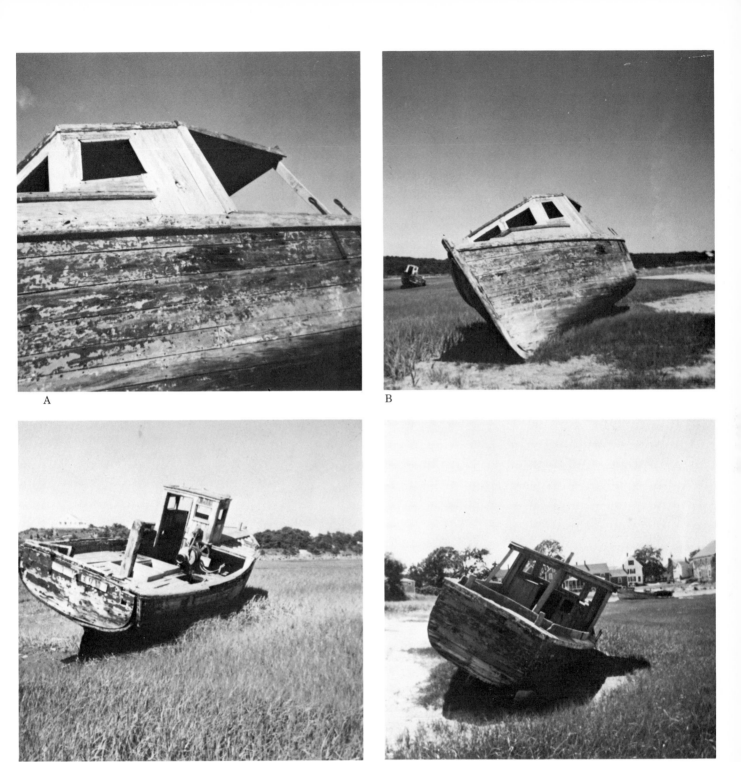

A

B

C

D

1. The Instamatic Photos. Photographs A and B are of the same boat; the former shows the beautiful wood texture and the latter, the shape and detail of the bow. The boat in photograph C has terrific shape and texture while the boat in photograph D has tremendous possibilities if I flop it.

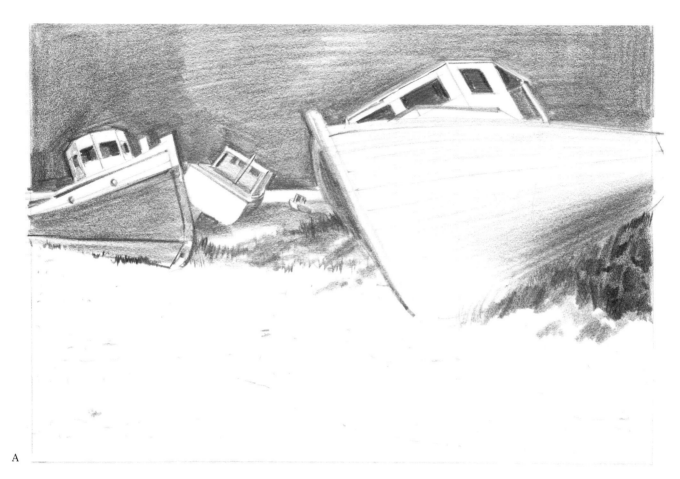

A

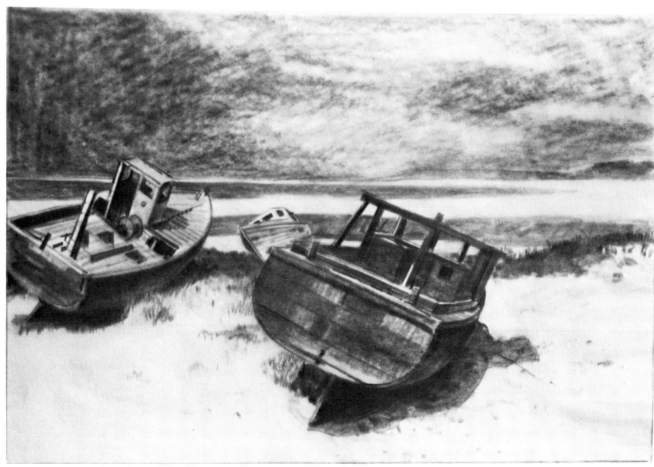

B

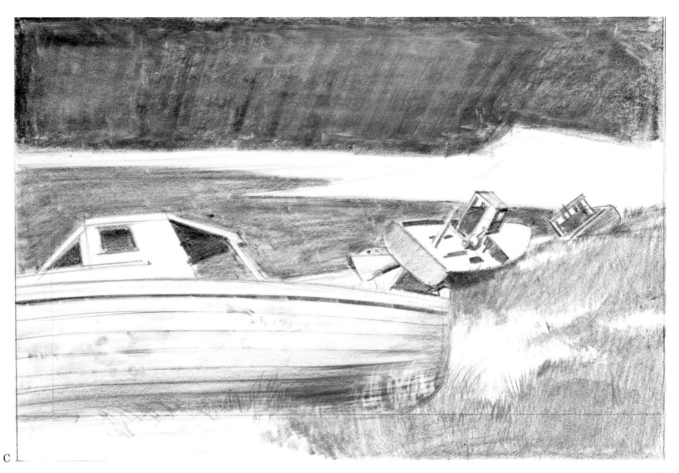

C

2. The Sketches. Sketch A was my first attempt to combine and assemble the photos into an interesting arrangement. It measures 8″ × 11¾″ (20.3 cm × 30 cm) and was done with an office pencil on tracing paper. I think this would make a nice painting, but it seems to lack the mood I want to develop. From the very beginning I visualized a sad and gloomy mood, with the sky dark, stormy, and oppressively hanging over the abandoned boats, and with only the sand glowing in an eerie light. In sketch B, which is 10¾″ × 16″ (27.5 cm × 40.6 cm), I've invented a sky and background that unifies the individual shapes of the boats. They were enlarged by eye, with just minimal detail, because I'm only trying to resolve shape, tone, and placement here. I've decided that sketch C, also 10¾″ × 16″, is the one to enlarge and refine for the final painting. Actually I was torn between this and sketch B, but the disposition of light and dark shapes here better conveys the isolation and the stillness of a graveyard. I mention the emotional aspects of picture-making because I can't stress too strongly that — even when using photographs — you, as an artist, must imbue your work with feeling or you'll end up with only copies of what the camera has seen.

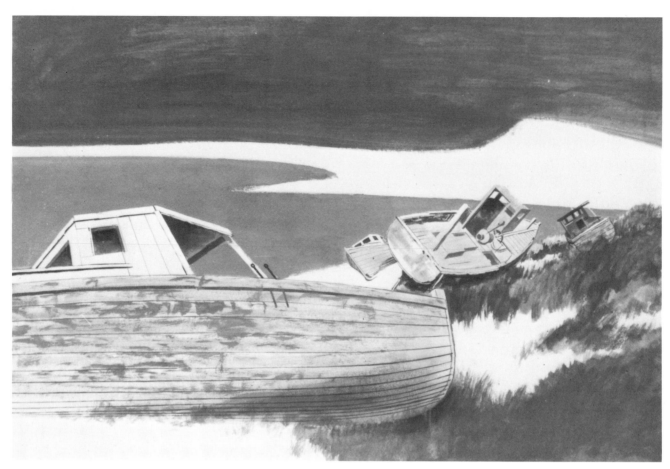

3. The Lay-in. I used the squaring-up method to enlarge the sketch to 20″ × 30″ (50.8 cm × 76.2 cm). Then, following my usual procedure, I traced this enlarged drawing onto a 20″ × 30″ Bainbridge illustration board. After tracing the drawing, and reinforcing some of the lines with black acrylic so they won't get lost, I begin the lay-in. I use very thin paint everywhere, because I want these colors to interplay with subsequent colors, and because I want to establish quickly the overall tonal scheme without covering up the traced line drawing that you can still clearly see. The brushes I use are flat sables Nos. 20 and 14, and the colors are: Liquitex Mars black, titanium white, yellow ochre, ultramarine blue, and cadmium red light. I lay in the sky first with the larger brush and black, white, and yellow ochre. Then I move over to work on the grass with the same colors but letting the yellow prevail, scribbling with the edge of the No. 14 in an up-and-down motion to get the character of the contours. Picking up the No. 20 again, I lay in the water with blue, white, and yellow ochre. The boats come next; I use a thin gray wash of black, blue, and yellow, but without mixing it thoroughly, so it has a variegated look of warms, cools, and neutrals. As I move back to the smaller boats, I switch to the Nos. 3 and 5 pointed red sables.

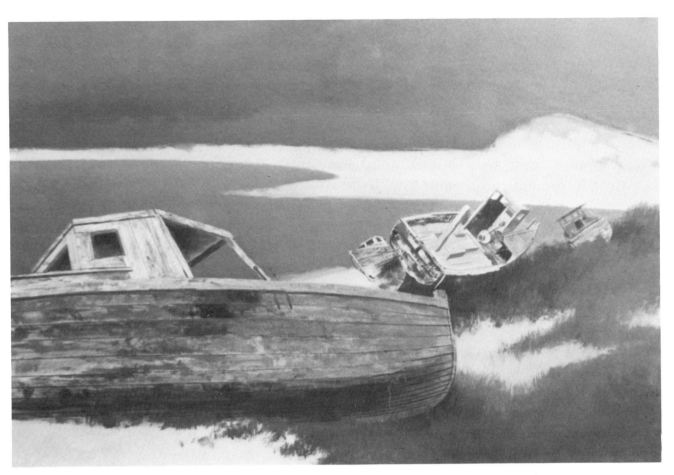

4. The Lay-in Continued. To kill the remaining white of the bare paper, I've given the ground up front and in the distance a pinkish gray tone, using cadmium red light, black, blue, and white. I also give the sky another going-over with the same colors as in Step 3, using the flat No. 20, and making it a bit lighter than before so it doesn't overwhelm the subject matter, and so it recedes. After the sky is lightened, the grass seems a bit too insistent, so I go over the grass with the same colors, only lighter and stressing the yellow. Using the broad side of a No. 14 flat sable and yellow ochre, blue, white, and a touch of red, I pat in a suggestion of the distant dunes. Then my attention shifts back to the boats and I start indicating some of their textures. I hope you've noticed that the middle boat, from photograph C, is tilted more here than in the photograph, to emphasize its inactivity. Now with every area laid in , I'm ready to begin painting.

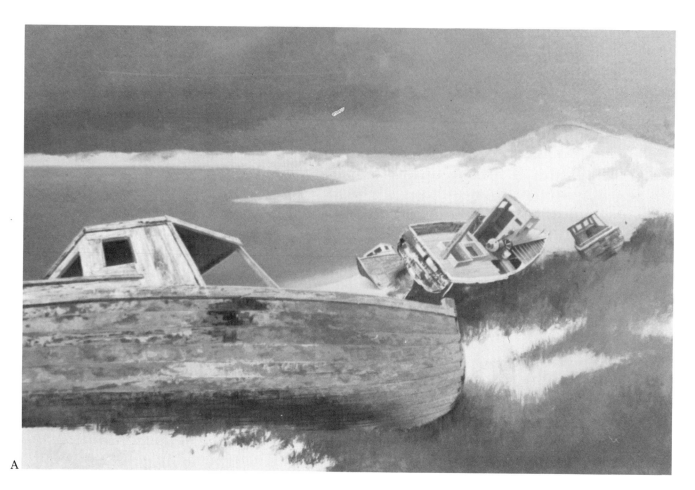

A

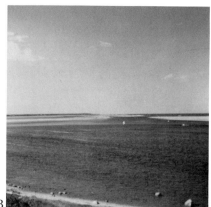

B

5. Painting Begins. Deciding I couldn't improve the sky, I left it alone and began adding more grass to the distant dunes, looking for the right shapes and high enough values to preserve the aerial perspective (A). I also lighten the water behind the flopped boat to bring it out. It was while doing this, that I noticed the swath being cut in the grass by this boat, and decided to play it up as a metaphor of her youth, when she was cutting it up on the bay. I'll use this photo (B) of a quiet bay to render the inlet properly. I continue working on the boats, adding textures and developing details. Notice that while doing this, I've obliterated (since I'm using thicker paint) the rods on the gunwale of the front boat. But it was preferable to get the edge of the water correctly, and the tone and texture of the stanchion supporting the canopy. The rods can be easily replaced by checking the line drawing. I've used the No. 3 watercolor brush with blue, black, yellow ochre, and white to render the bare weathered boards of the hull of the first boat, as well as the original coat of blue, and the subsequent coats of green that she wore in her later years.

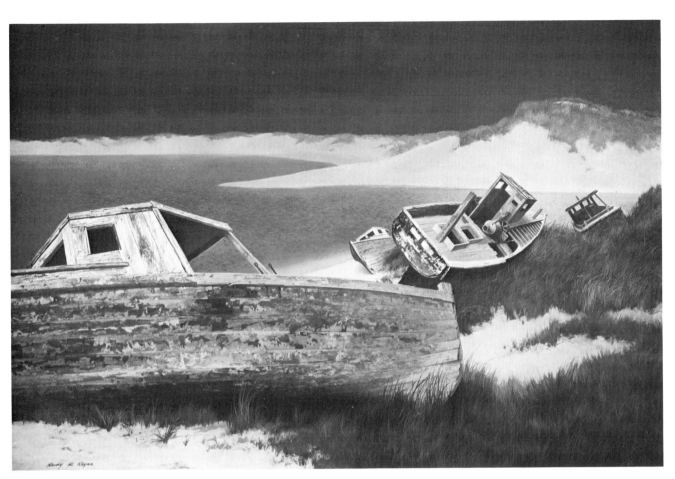

6. The Finished Painting. At this last stage you can begin finishing anywhere, but I picked the distant dunes, probably because it's my procedure to work from the back forward. I pat the broad side of a No. 8 flat sable against the top edge of the sky and work downward, retaining, adding, and modifying some of the shapes. Then, using thicker pigment, but following the same color and value, I do the dunes, still modifying and correcting some of the shapes of the grass, as you can see. Now, again consulting the photo of the bay, I indicate the ripples on the inlet with a No. 2 watercolor brush and ultramarine blue, yellow ochre, and white. Next, I tackle the grass, adding more vermilion to give it that burned look of fall and winter, and resting my hand on a mahlstick for greater freedom as I swing my brush in broad, upward strokes. Then on to the boats to give them their final smaller details. Note that, to be consistent with the mood of the painting, I've done away with the sharp cast shadows shown in the photos taken on a sunny day. Always keep in mind the *overall* effect you're trying to achieve. When assembling individual photos, you must subject their contents' size to the rules of linear perspective, and texture and color to those of aerial perspective, so that the final result is a coherent and convincing visual statement as a whole, and not a hodgepodge of separate observations put together within a frame.

PROJECT 7
Photographs and Sketches

I'm eager to describe this approach to picture-making because it reaps the best of two fields. A painting like this can be triggered either by a sketch that requires further information from photographs, or by a photo that needs the aid and support of a sketch. The combination of the facts of the photo and the spirit of the sketch can lead to a perfect balance. I hope that you have a few sketches and enough snapshots to make a happy combination.

B

A

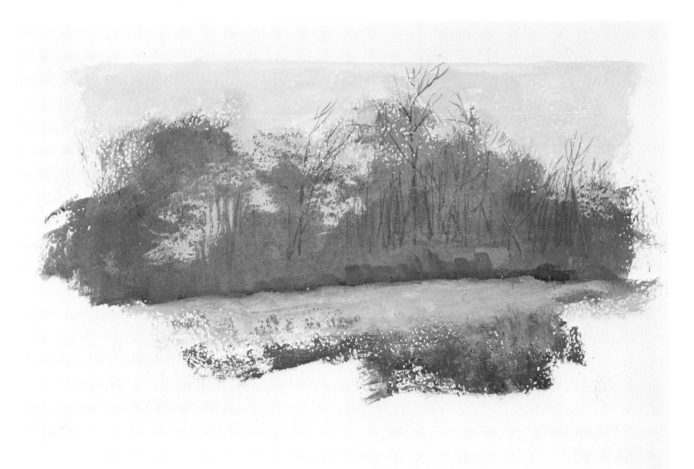

D

1. The Photos and Sketches.

The central figure in this painting is a tree (A), which I shot with my Instamatic during one of my walks. The light was just right to bring out the form and texture of the tree and I could see that it lent itself to modifications in the arrangement of the branches and the girth of the trunk. I want a bright spot in the painting, and since I haven't been able to snap any cardinals in the woods near my studio, I consult the dictionary and find an illustration (B). Not very good, but it gives me an idea of the bird's shape and markings. Rummaging through my sketch bin, I come upon a sketch (C). I take the biggest of the rocks and modify its shape to suit my purposes here. Now I just need something to unify the elements—a band of trees would do the trick. Looking out the window, I do a quick sketch (D).

C

2. Preliminary Drawing. Using an office pencil, I set the tree down on a 9¼" × 22" (24.1 cm × 55.9 cm) sheet of paper. I use transparent tracing paper so I can slide photos or sketches underneath it to see how they will look before I draw them in. I make the tree much thicker and eliminate most of the branches and twigs. I also shift the post away from the trunk to balance the composition. I flop the illustration of the bird so the strong vertical of the tree won't block its imminent flight. I incorporate the rocks and forest, and my preliminary drawing is finished.

3. Beginning to Paint. With a 9H pencil, I transfer the drawing to a piece of Bainbridge No. 80 double-thick board which is also 9″ × 12″. (If you find this size painting surface too small, you can, of course, enlarge the area.) I set my Marabu opaque watercolor box on the butcher's tray, and wet the following colors: burnt umber, yellow ochre, ultramarine blue, and black. I also dip into the jar of Rich Art white poster paint. I begin painting the texture on the trunk, using the heel of a No. 3 watercolor brush. The sky is a light gray with hints of yellow ochre, and the band of trees is a medium gray with whispers of yellow ochre and burnt umber. You can barely see the traced outlines of the rock and the post, but they are still there.

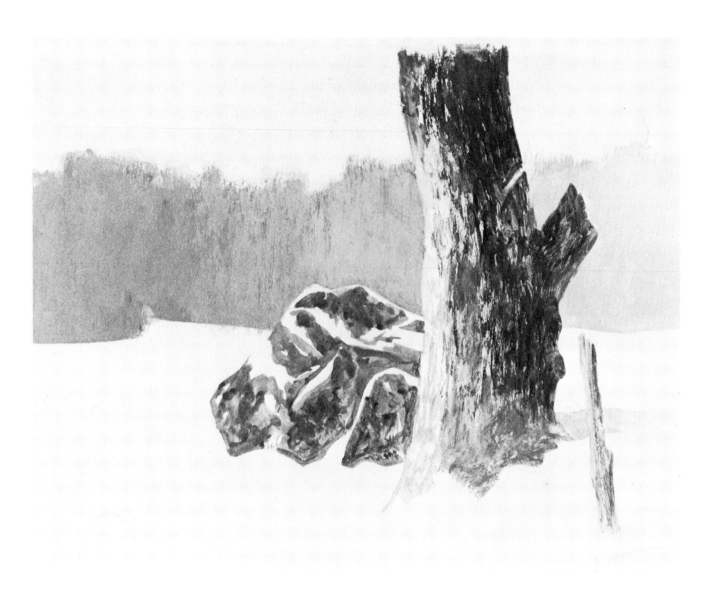

4. Major Shapes Painted In. Using the No. 3 brush with burnt umber and ultramarine blue, I indicate the rock in very thin pigment. The whites suggesting the snow—as well as those on the rock and tree —are simply the bare board. I move over to the post and paint it with a No. 2 watercolor brush dipped in yellow ochre and burnt umber. It's at this intermediate stage that you can tell whether a painting should be continued, put aside for further development, or even thrown away as worthless. However, here I feel I've got something especially good.

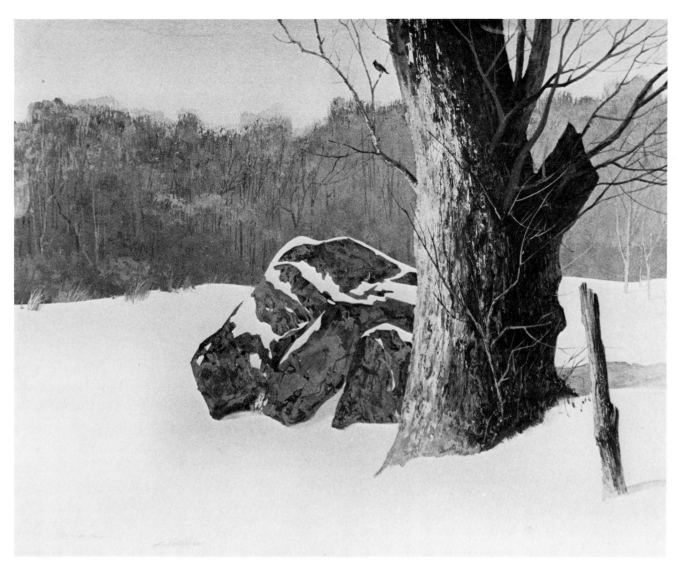

5. The Finished Painting. Now I place the drawing back over the painting and retrace some of the branches that I painted over while doing the sky and the woods. When the background is done, I can also trace in the bird. Of course, I can't paint a cardinal with the restrained colors I've used so far, so I wet the cadmium red in the Marabu box, check the drawing in the dictionary, and render it with a No. 00 brush. I move over to the woods and refine them, then finish the rock, the trunk, and the post—giving each element its appropriate texture.

PROJECT 8
Multiple Prints from Same Negative

There were many photographer-painters at the turn of the century; men who took their own photos to use as material for their pictures, and sometimes even painted in oil right over their photographs. I have a notion it was one of these chaps who, unable to decipher certain details as he worked, decided to make another print that would show what he wanted by under- or overdeveloping it. This is only an assumption. I don't really know who was first struck with such a clever idea, but I don't think a painter unacquainted with the processes of photography would have thought of it. I came upon this procedure — referring to normal, dark, and light prints of the same photo for details — at Illustrator's Group in New York City and used it extensively in commercial work. I don't see why it shouldn't be of service to the painter as well.

For this project, I'll use Nupastels made by Eberhard Faber. They come in sets of four warm and four cool sticks, and their sharp corners make for easy detailing, while their broad sides quickly cover the larger areas. It's a good idea, though, not to use the cool and the warm in the same picture; the combination can become most unpleasant, and when working for reproduction, the cool areas may photograph lighter than they really are. Anyway, I use the four warm sticks, ranging from dark to light gray, and I depend on a Koal-Blak 6B charcoal pencil (also by Eberhard Faber) for the blacks, and a Conté pastel pencil for the whites.

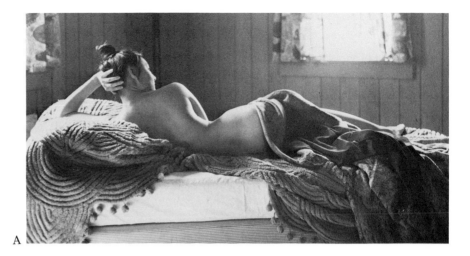

A

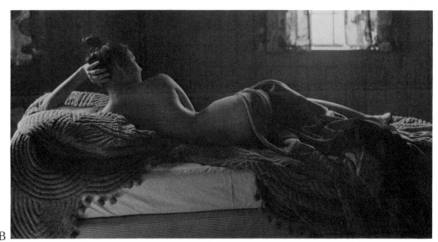

B

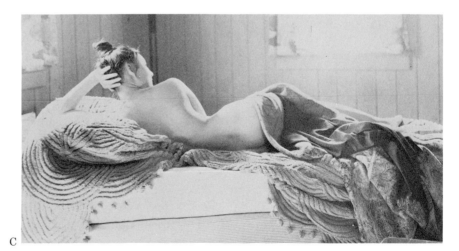

C

1. The Three Prints. These are 8″ × 10″ (20.3 cm × 25.4 cm) black and white glossy prints I asked my photographer to develop for me. The first print (A) is normally developed and it shows the tonal scheme as it should be. The second print (B) is overdeveloped so that the detail in the light areas, such as the sheet and the modeling on her left arm, is brought out. The third print (C) is underdeveloped to show up the dark areas, for example, the details on the body that would otherwise be lost in shadow. Now, if the job doesn't come off, it won't be because I lack information.

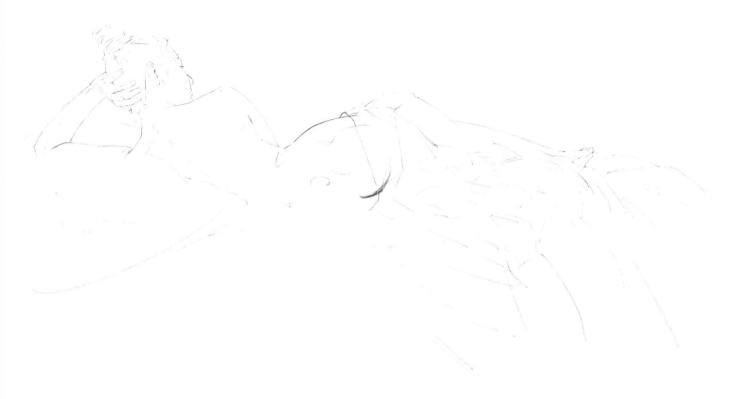

2. The Line Drawing. I put the normal print in the opaque projector and, using an office pencil, enlarge it on 19″ × 24″ (48.3 cm × 61 cm) Aquabee tracing paper to an area 18″ × 32″ (45.7 cm × 81.3 cm). Since the only projector I could rent takes nothing bigger than a 5″ × 5″ photo (14 cm × 14 cm), I enlarge it in two sections. First, I do the torso, then shift the photo in the projector to get the rest of the figure. As I set down some of the shapes, I realize that they will have to be changed or modified, but this sort of thing is done later, in the full light of the studio and not in the semidarkness required by the projector. But even if there were no changes necessary, I would like to point out that what I've established here is no more than a "map"—the cold and unfeeling boundaries and topography of the subject.

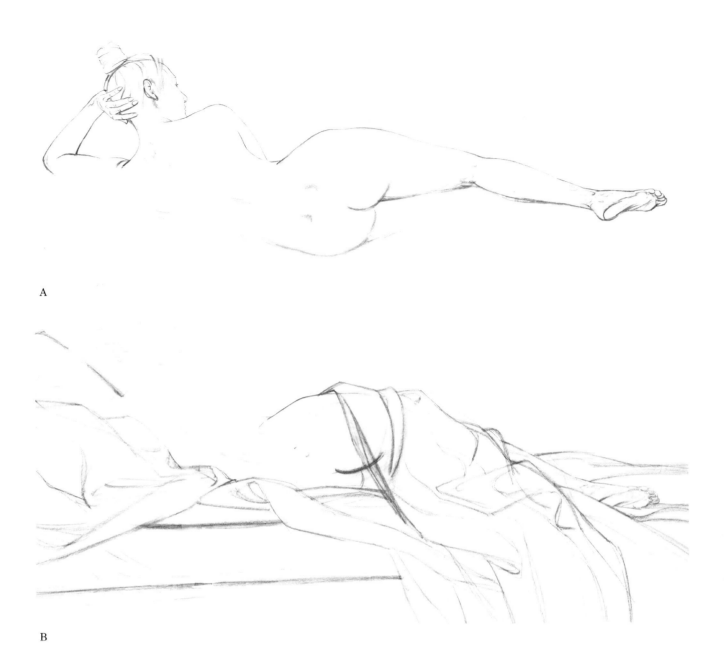

A

B

3. Corrections and Modifications. Now, off the wall and back onto the drawing board, I tape together fresh sheets of tracing paper (from the same 19″ × 24″ tracing pad), place them on top of my preliminary drawing and work out the changes on the figure that I had anticipated when enlarging. (See drawing A.) To begin with, the left arm was unduly stretched out, making too big a shape, even in line. So, I push the elbow away to form a smaller triangle. Next, the 1-2-3-4 arrangement of the fingers (that I failed to notice when the photo was taken) must be regrouped more pleasingly; I close up the two middle fingers into a single unit. However, the most offensive part of the drawing is the foot, although I don't know why. It looked perfectly all right in the photograph, and then became almost deformed in the drawing. Check it in the preceding step. I've done the previous corrections without the model, but for this major operation, I pose her again and draw the foot from life, bending the leg toward the viewer to get a deeper curve beginning at her hip, and a better shape of the foot. I also shift the figure away from the horizontal position shown in the photo because, even though at rest, she shouldn't look fizzled out and collapsed. Again, consulting all three prints, I slip the drawing under fresh tracing paper and refine the folds in the sheet (B).

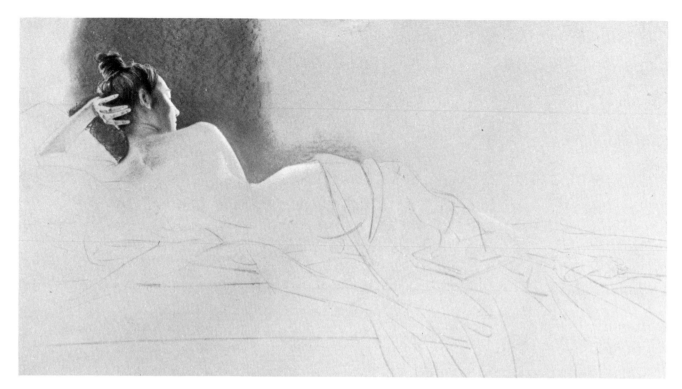

4. Beginning of Pastel Application. As is my usual procedure, I trace my final drawing onto a medium-textured, light gray matboard, 16½″ × 40″ (40.6 cm × 101.6 cm). I place all three prints at the top of my drawing board, consulting each one for the clearest detail. I use the broad side of the medium gray pastel stick for the large area behind the head, smoothing it out with my fingers but leaving some of the board's texture as a contrast to the smoothness of the face and body. I establish the darks of the hair with the charcoal pencil, and the lights with the pastel pencil. Where an area becomes too small to be blended with my finger, for example, the hand and the ear, I switch to a paper stump.

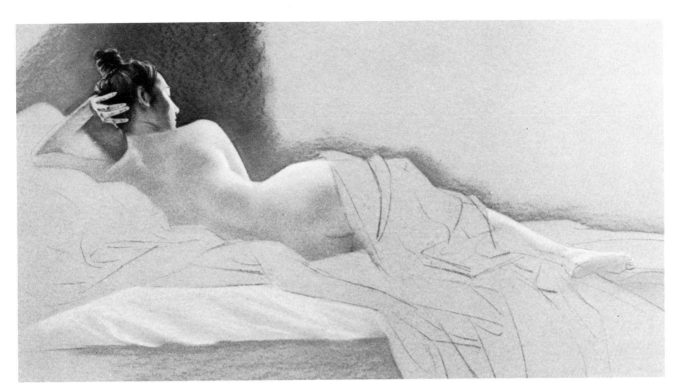

5. Continuing the Tonal Applications. Since I want a smooth texture for the figure, I rub the medium light gray pastel stick on a piece of sandpaper and let the powder fall in a dish. Then I tap a wad of cotton into the powder and rotate it gently on her torso. The tone isn't as dark as I want it yet, and the modeling is only vaguely indicated, but I must cover this area before proceeding to the drapery on her thigh and to the sheets on the bed. I think I'll do away with the bedspread because all that ribbing is too distracting. Of course, I'm still consulting all three prints as I develop the painting; there are things that are hard to see in one and quite clear in another. When I articulate the small details of her features, I rest my hand on a mahlstick so I won't disturb this fragile medium. A painting in pastel can be fixed, but there's always the risk of discoloration. I prefer to rub the medium quite vigorously so that no excess powder remains on the surface.

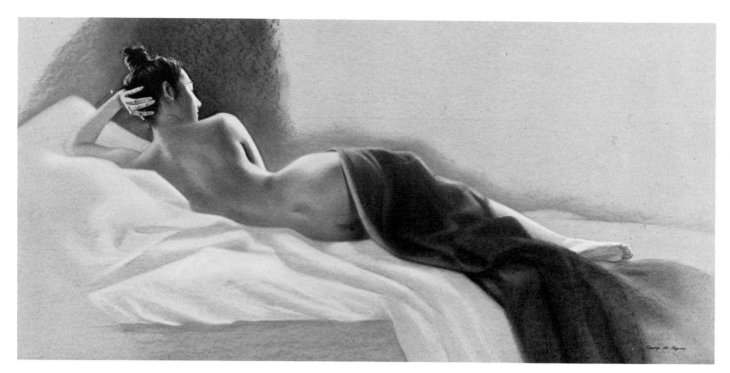

6. The Finished Work. Checking the dark print, I give the last touches to the left arm, but keep it light in value to subdue the X it forms with the edge of the pillow behind it. Having solved this problem, I'm now confronted with an "asterisk" made by the edge of the pillow, the upper arm, the left shoulder, and the edge of sheet underneath it. Confound the blasted thing! I read long, long ago that "a work of art suffers innumerable changes," and didn't know what the bloke meant then. Believe me, I do now! Oh well, I said pastel is an easy medium. To correct this, I raise the edge of the pillow (inside the crook of the arm) by first tapping the area with a piece of kneaded eraser. Then I apply the light gray chalk and smooth it with my finger. I go on and apply the dark gray stick to a portion of the cloth covering the thigh so as to better judge the tone of the flesh. I model the torso with a wad of cotton and powder from the darker sticks, going slightly past the cloth and the sheets; I will clean up the edges later with the kneaded eraser. When finished, I could either mat and frame this nude, or keep it as a study for a painting in another medium, with only the problem of color remaining to be solved. (This painting reproduced courtesy of Mr. and Mrs. Jonathan Fitch.)

Sequential Photographs for Panorama

A valuable photographic device I learned from Mr. Norman Rockwell is: take two or more photos of a subject that's too large for just one, shooting deliberately at close range for highly detailed photos, and planning sequential shots of a panoramic view. I'm sure there are other expedients that you'll discover for yourself as you snap around. The Instamatic has been my constant companion since I started this book, either in my pocket or as part of the equipment in the car. Why not take your Instamatic now and shoot that panoramic landscape you've been wanting to paint.

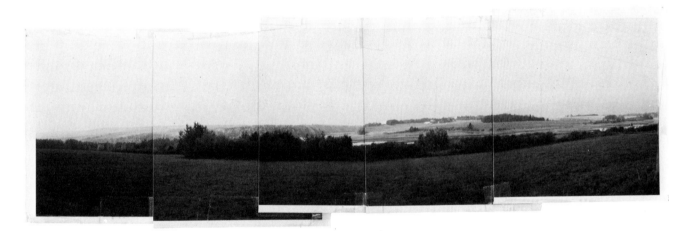

1. Successive Shots. Photograph whatever you find appealing and make a note of the quality that attracted you to it—its color, texture, light and shadow pattern, or whatever you think will lead to a good painting. This is important because it's easy to get sidetracked later when the painting is underway. I took these Instamatic shots while driving along the Connecticut River. I was so struck by the beauty and tranquility of the scene that I took these five snaps.

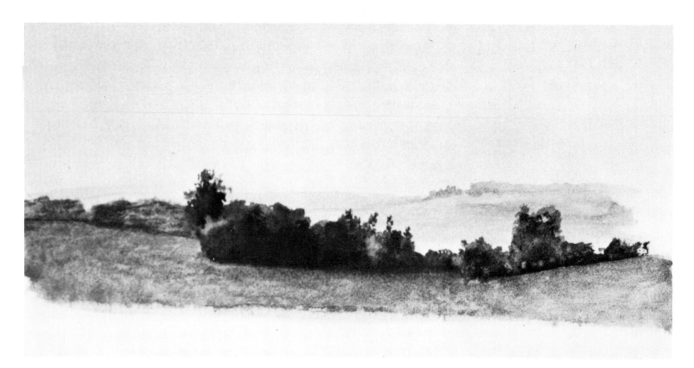

2. The Color Sketch. First I do a quick 6″ × 12″ (15.2 cm × 30.5 cm) sketch, making the necessary changes and modifications from the photos. Using Nos. 3 and 5 Winsor & Newton watercolor brushes, and a palette of Indian red, yellow ochre, green 1, blue 1, and black from the Grumbacher Brilliant watercolor box, I try to saturate myself with the feeling of peace I experienced when viewing the actual scene—the beauty and color of the landscape, the smell of the grass, the sound of the birds, the gentle breeze. Robert Henri was so right when he declared that painting requires all the senses. Among the visual aspects I want to emphasize are the rolling grassy foreground, the sense of quiet conveyed by the horizontal format, and the feeling of great space as the view unfolds into the distance. For this last feature I rely on the contrast of warmer colors in the foreground against cooler values in the background. No doubt there will be other variations to consider as the work progresses, but so far I'm satisfied not to lose it in the drawing; any further deviation must lead to a better piece of work.

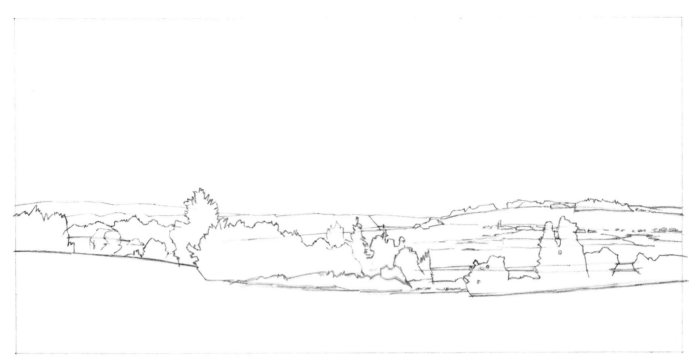

3. The Line Drawing. Using an office pencil on tracing paper and checking both the sketch and the photos, I enlarge by eye the contour of the groupings as well as the gaps between the trees. I try to make the enlarged arrangement as pleasing as possible without destroying the serenity of the place. The drawing measures 32″ × 60″ (81.3 cm × 152.4 cm). Not that I like to work this big, but a gentleman saw the sketch and commissioned a painting this size to fit a certain space in his living room. Now—shades of my commercial art days—the painting *has* to come off or I'll be in trouble!

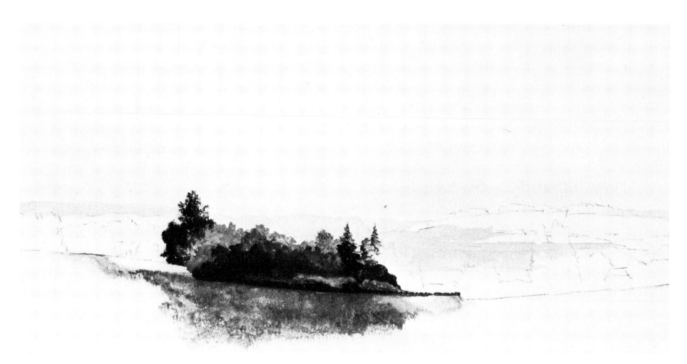

4. Beginning of Underpainting. I've set on the butcher's tray the nest of saucers that I use when I require larger than usual amounts of paint. Checking the sketch, I prepare these colors in egg tempera: alizarin crimson, American vermilion, burnt umber, yellow ochre, cobalt blue, ivory black, and titanium white. I use very thin pigments with a No. 20 flat sable, and Nos. 3, 5, and 9 watercolor brushes. The support is a Bainbridge illustration board No. 170, 40″ × 60″ (101.6 cm × 152.4 cm). I begin painting in the distant background with mostly white and whispers of crimson, cobalt blue, and yellow ochre. Then I indicate the middleground with the same colors, but adding a bit more yellow to warm them up. For the dark mass up front, I dip into the vermilion, burnt umber, and ultramarine blue; this gives the large clump of trees their autumnal color. The tallest tree is a mixture of ultramarine blue, yellow ochre, and black. I work on all three planes of the picture at the same time to set down as quickly as possible their relationships to one another in color and value.

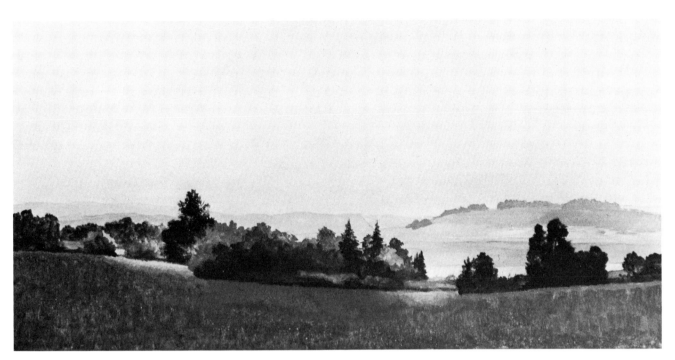

5. The Underpainting Completed. The partly cloudy sky is so soft that I doubt the reproduction in this book will show any configurations. Anyway, everything is finally covered and there's no trace of the transferred drawing. As I work on this lay-in, it occurs to me that perhaps a couple of sunlit spots on the ground would add interest to such a large painting. If I find that they become a bit theatrical, I can always paint them out, but so far I like the effect. I'm still using thin pigment and not thinking of details or the character of the edges — these will be rendered properly when I begin to paint. I obtain the texture of the grassy foreground by patting the No. 20 flat sable all the way across the five foot expanse of the board.

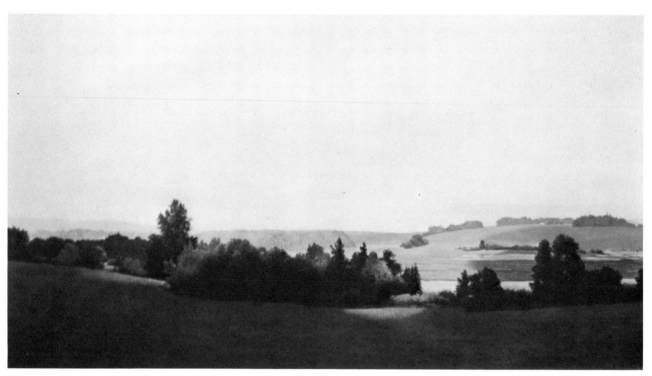

6. The Finished Painting. Now with shape, color, and value established, I can take up any section of the picture and start the final rendering. In this case, I begin in the distance and work my way forward to the edge of the river and a bit into the contour of the trees. I'm using slightly thicker pigment, but even so, the edges remain clearly visible because of the transparency of this medium. Then, with the No. 9 brush, I tackle the sky, using a lot of white plus cobalt blue, yellow ochre, and alizarin crimson. Next, I regain the shapes of the trees, taking care to feel their bulk, as well as their soft and firm edges. I apply deep, medium, and light green mixtures of ultramarine blue, yellow ochre, and burnt umber — with touches of black in the shadows, and white in the lights. The last section rendered is the grass in the foreground. Here, I use Nos. 5 and 9 watercolor brushes to refine the rough texture previously layed in with the No. 20. (This painting reproduced courtesy of Mr. and Mrs. John Isham.)

PROJECT 10
Altering Values

There was an avalanche of photographs from my friends when they learned I was doing this book. Most of them are camera buffs, and therefore I was amazed to see how many of them had under- or overdeveloped their prints. Were they making them so dark that you could hardly distinguish the subject matter in order to make them "dramatic"? Or leaving them so light (with the same results) to make them "poetic"? I don't know, and I didn't ask because one doesn't look a gift horse, etc. When I inquired if the negatives were available, I was told they had either been misplaced or lost. Pity, because some of them have tremendous possibilities, even though they lack clear information. But, and this is the point of this project, even if detail is hard to read, don't discard a photo with arresting shapes only because it's photographically weak. As an artist, here's where you come in to do the necessary adjustments.

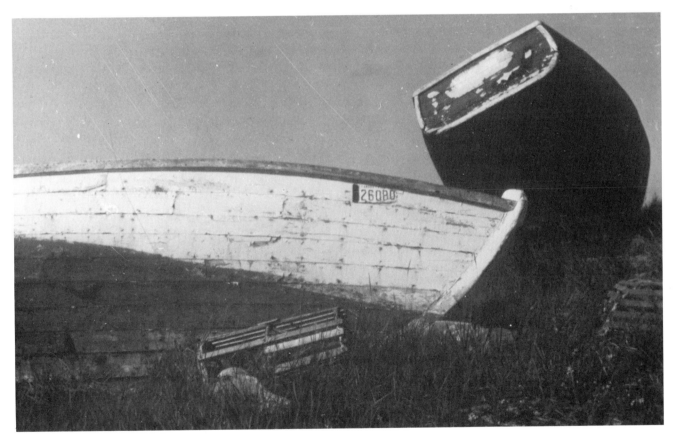

1. Photo with Weak Tonal Scheme. Here's a good example of a photograph with wishy-washy tones, and yet there's something so exciting about the shapes that it bears investigation. The extraordinary position of the boats compels me to fetch my Marabu color box and dash off a sketch and see what develops. If nothing does, then I'll go on to the other photos to see if they have anything to offer. As I scrutinize this one with my peepers, I can see many things that escape the naked eye; I'm encouraged to proceed.

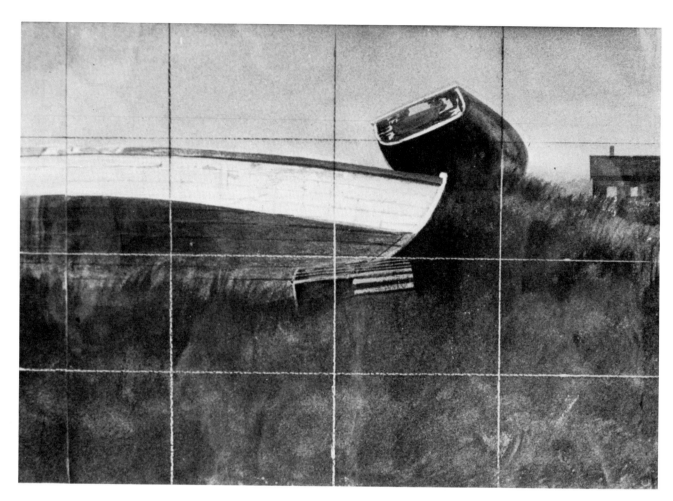

2. The Tonal Sketch. I put the Marabu color box on the butcher's tray, get a jar of clear water, grab a piece of Fabriano watercolor paper, set a roll of paper towels on the taboret, pick Nos. 3 and 5 watercolor brushes from the pot, and—I'm off on this exciting venture. I'll do the sketch in watercolor, using transparent washes of Indian red, yellow ochre, ultramarine blue, and black, with no white, except where I might need a bit of touching up. (The Marabu pigment can be used both as transparent or opaque watercolor.) I add a shack to calm the downward thrust of the black boat, and so the eye continues on a smoother path to the right edge of the picture. I also lower the black boat a bit because it seems to be teetering; besides, I need more space between it and the top edge of the picture. Just one more thing—when working in transparent watercolor, be careful to leave the whites untouched. Use no white pigment, so the lightest areas are the bare paper itself. When I'm satisfied with the sketch, I draw a grid on a sheet of acetate placed over it; I will use the squaring-up method to enlarge it.

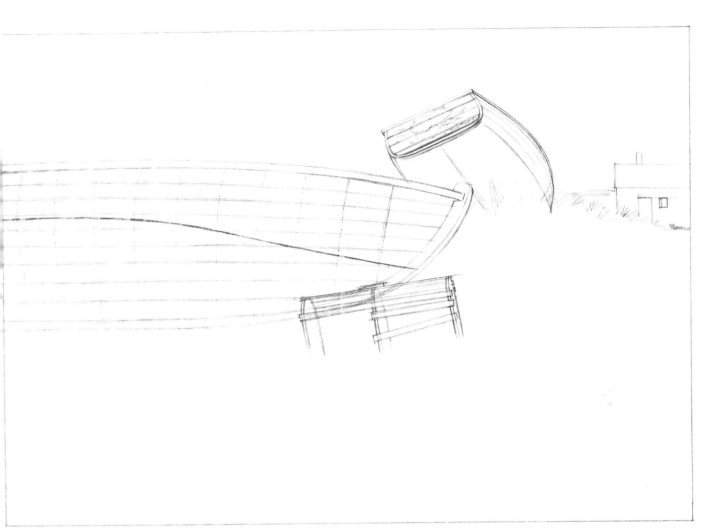

3. The Line Drawing. After inspecting the photo with my peepers for whatever information it could yield, I enlarge my sketch to 12″ × 18″ (31.7 cm × 45.7 cm). I have no trouble "reading" the boats and the lobster pot, but the grass is almost illegible. No matter—I've painted grass so often that I can do it from memory. (I would suggest, however, that you get a photo showing grass, or go out and sketch it.) I drop the waterline on the hull of the white boat to the sixth plank as the photo shows because it makes a more interesting shape. I keep the position of the lobster pot to convey the "bone in her teeth" metaphor, and to anchor on its straight lines the curvilinear structure of both boats.

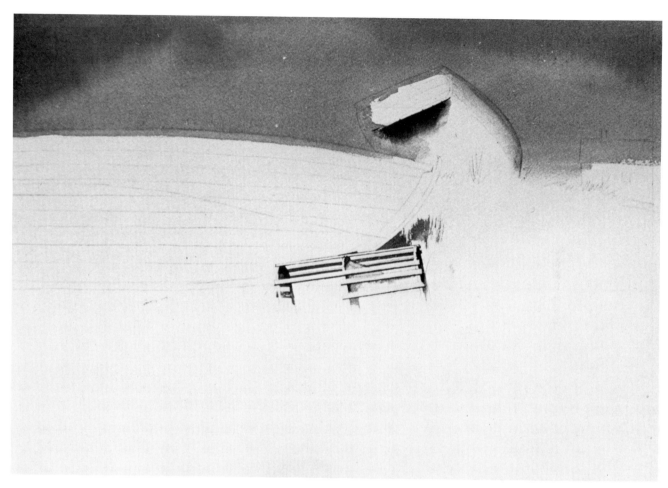

4. Beginning of Painting. Here's the line drawing transferred to a 15″ × 20″ (38.1 cm × 50.8 cm) piece of Fabriano watercolor paper. (Watercolors can also be done on illustration board. However, I find it more inviting to float washes on paper, which has been taped to chipboard or matboard for easier handling when turning and tilting.) I switch to the "Brilliant" watercolor box by Grumbacher. I prepare a mixture of black, green 1, and yellow ochre in a saucer, and test it on the edge of the paper for color and value. Remember that watercolor dries lighter. Next, I dampen the sky area with a No. 20 flat sable and water, and wait until it stops glistening. Then I take some of the mixture in the saucer and add about the same amount of clear water to it to make it lighter. Holding the paper at a 45° angle and using the No. 20 brush, I stroke this lighter wash across the top. I recharge the brush as I bring the wash down to the contour of the boats. Notice I've gone slightly past the outlines; when the wash dries, I can regain the edges by simply scraping the pigment off with a razor blade. But now, I quickly rinse the brush in one of the jars (I keep the other filled with clear water at all times), and wipe it on a paper towel. Then I apply the original mixture while the flat, light wash is still wet, so that the darker tone spreads softly to give me the appearance of dark clouds. While the sky dries, I place a dark note on the bottom of the black boat so I can judge the intermediate tones I'm about to apply. I used pointed watercolor brushes Nos. 3, 5, and 8 to indicate the lobster pot so that I won't run any of the surrounding darker values into the light slats. The thing to keep in mind when using this medium is that the whites are achieved by leaving the paper untouched. I'm a purist when handling transparent watercolor. You can, of course, touch up minor errors with Chinese white, but I'd rather see what the medium can do.

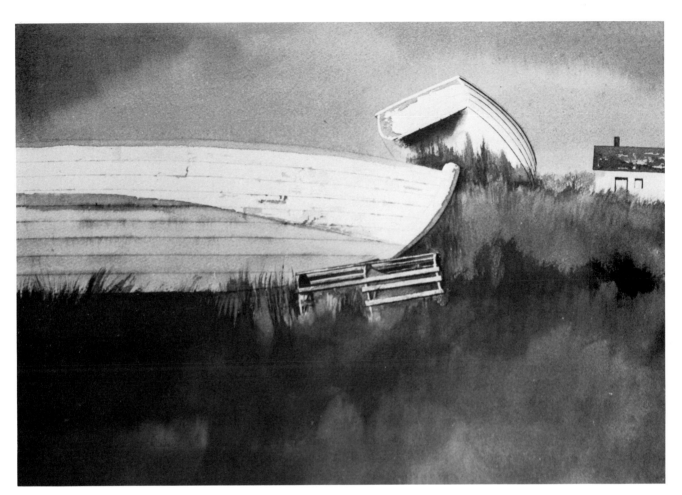

5. Main Shapes Painted In. Not wanting to lose the ribbing on the black boat (hardly visible even with the peepers), I secure them with India Ink. This will allow me to rub watercolor over the lines without disturbing them because the ink is waterproof. I've regained the white edge of the stern by scraping the pigment off with a frisket knife. Then I move over to the shack and paint the chimney and the roof. At this point, I wonder if I should leave the wall as light as it is—we'll see. Now I do the lines on the hull of the white boat in watercolor, because this time I want them to spread when I wash the Indian red and black mixture up to the waterline. Now using raw umber, yellow ochre, and black with the No. 8 brush, I quickly apply the grass, dipping my brush into more pigment for the darker areas and into the water jar for the lighter ones. The paper begins to buckle, but it'll flatten out when the color dries. So far so good. I can see why many artists prefer this medium to all others. It's so exhilarating and quickly done that if something doesn't come off, the whole blooming thing can be thrown away and a fresh start begun all over again.

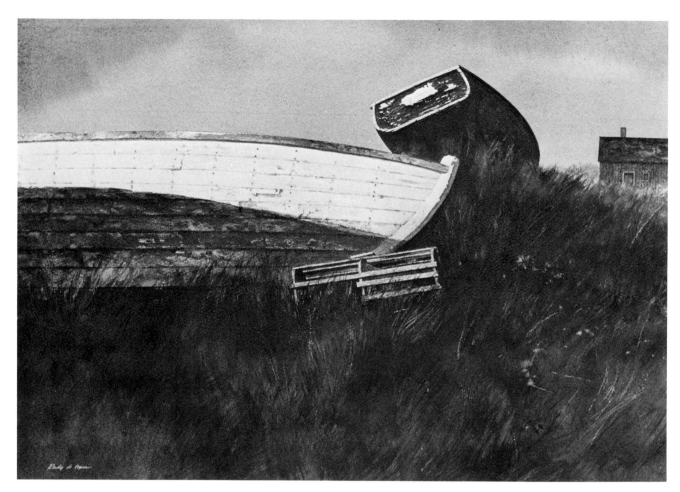

6. The Finishing Touches. After the paper flattens out, I use a razor blade to scrape the whites on the gunwale of the white boat. I place the pencil drawing over the painting, and then, with a sharp 9H pencil, I use the lines across the hull as a guide to indicate the placement of the rusty nail heads. Some of them came out too dark, so I tap them off with a kneaded eraser. Doing one vertical row at a time, I touch each dot with a No. 3 brush, moistened with water. Then, I quickly charge a No. 1 brush with a mixture of Indian red and yellow ochre, and touch the center of the little wet area so that the color spreads, giving me the rusty spots and nail heads. I render the weathered red on the hull with Indian red and black, sometimes using the point and sometimes the side of a No. 5 brush to get the texture. With a No. 3, I do the grass under the black boat and finish the dark hull (black, raw umber, and green 1) while the edge of the grass is still wet. Now I know I don't want another light note on the shack and so I kill the white with a warm gray. I continue to render the darker lines on the grass and scratch in the light leaves with the corner of a razor blade. For the weeds, I pick out the light shapes with the point of a damp No. 1 brush, reapplying the brush as many times as necessary to lift the pigment. The last things I do are the minute details on the lobster pot, and the grass overlapping it.

Correcting Photographic Distortion

Originally I thought I might retain and play up the distortions found in some photographs, using them to convey either the nobility or the baseness of man. His puny brain or his narrow-mindedness when the head photographs too small; his swagger and pomposity when the head turns out too big. His Sancho Panza aspect when the camera squats his figure, or his Quixotic tendencies when it elongates it, etc. But since these speculations belong to the realm of philosophy and social commentary, I'd be indulging personal observations and not dealing with the more common and practical normalizing of distortion problems. As a matter of fact, our purpose as artists should always be not just to bring things back to standard, but to lift them even beyond, to ideal concepts.

1. The Photograph. This woman is charming, vivacious, and elegant, but the photograph missed all these qualities, and adding insult to injury, made her even broader than she is! No question that an Irving Penn or a Richard Avedon photograph would have captured her spirit and grace, but we're dealing here with the efforts of nonprofessionals. This is a good photo for our purposes, however, because it has the information we need, and all that needs to be done now is to correct the faulty areas.

2. The Sketch. This sketch is to check the proportional corrections I mentioned, and to work out a tonal scheme. It's 10″ × 8″ (25.4 cm × 20.3 cm), done in Gamma grays, on Color-aid gray No. 2 paper. I'm using watercolor brushes Nos. 2 and 3. The color of the paper shows through on the window and the flesh, with modeling done in lighter and darker tones. Compare my sketch with the photograph. Notice how I remove the busy pattern of the shutter and replace it with the simple shape of the curtain; subdue the light on the window, chair, hair, shoulder, and arm; "kill" the light on her lap; simplify the shape of the chair's "wings"; and eliminate the other furniture. These corrections all help lead the eye to the center of attention, the head. I thicken the hair for a better shape, lengthen the neck and torso, reduce the waist, lift the chin a bit, refine the shape of the left hand, and lengthen the gown. As you can see, some of these changes aren't to correct distortions but to lift the subject beyond the factual. The duty of the artist is to be not merely true, but enchanting.

3. Line Drawing from the Photo. I enlarge the photo on a sheet of tracing paper 24″ × 18″ (61 cm × 45.7 cm). With an office pencil, I follow the image exactly as it's thrown on the wall by the projector. This gives me a basic contour, a starting point, from which I can easily develop a final drawing, modified and improved according to my previous sketch.

4. Corrections and Modifications. Now I place a piece of acetate over the sketch done in Step 2, and draw a grid with a white Stabilo pencil. I take another sheet of tracing paper and draw a grid 24″ × 18″. I place this sheet on top of the outline done with the projector and retrace it, at the same time referring to my sketch for placement of the corrected elements within the sections of the grid. I also refine the shapes and contours, clarify the folds, and strengthen the line. As you can see, this drawing combines the basics from the photo, and the refinements I considered essential from the sketch.

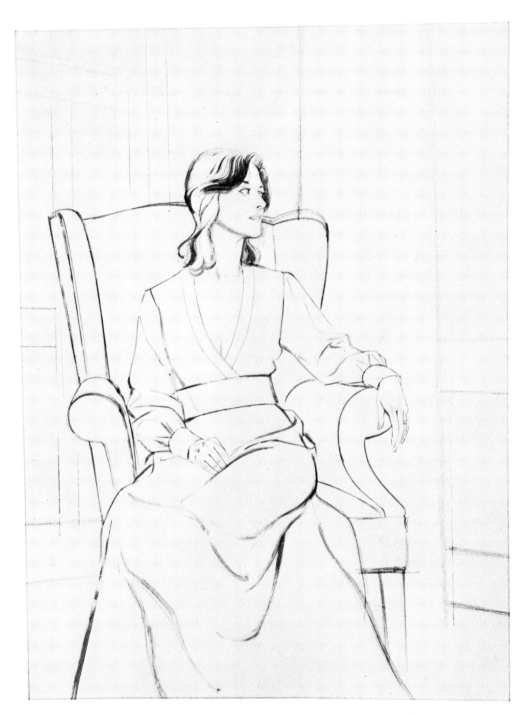

5. Securing the Drawing. Using a 9H pencil, I trace the line drawing to a Bainbridge No. 80 illustration board 30″ × 22″ (76.2 cm × 55.9 cm). I then secure the drawing with a mixture of raw umber and ultramarine blue acrylic; this medium won't blur or disappear as the pencil line would, when I later apply the acrylic tonal washes. I have a dab of each color on the butcher's tray and I mix them on my No.3 watercolor brush as I work, warming the line with more umber or cooling it with blue; this clearly establishes what will be the warm or cool areas.

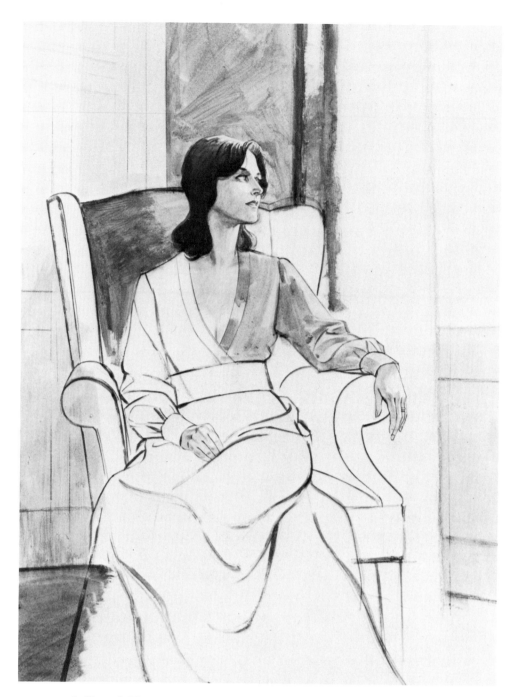

6. Tonal Washes. Now working quickly all over the picture with the Nos. 5, 14, and 20 flat sables, but still using only raw umber and the ultramarine blue acrylic, I apply thin washes to develop both the tonal and color schemes. I let the umber predominate on the wall, the gown, and the floor, while the blue predominates on the flesh, the chair, the curtain, and the woodwork. Notice that I'm not yet concerned with the character of the edges or with the brushwork; my purpose here is only to cover the disturbing white of the paper as quickly as possible. Note also how, in acrylic, the line remains distinct under the washes I've floated.

7. The Acrylic Underpainting Completed. Now that the entire board is covered, I can begin to paint using Grumbacher opaque watercolors and watercolor brushes Nos. 1, 3, and 5. My palette consists of flame red, yellow ochre, cobalt blue, green deep, burnt sienna, raw umber, black, and white. I begin on the cool flesh areas, using thin mixtures of flame red, yellow ochre, cobalt blue, burnt sienna, and white. I drybrush the soft modeling of the face and hands, taking care not to cover completely the cool underpainting so that the interplay of the blue-gray underneath and the pinks and ochres on top give me the iridescence of the fair complexion. Painting only small sections of the separate areas gives me a chance to see whether I should proceed with the hues, the values, and intensities I'm considering. I also begin at this time to think of textures and their corresponding soft or firm edges.

B

A

8. The Finish. When I finished the underpainting, I stepped back to view it from across the room and judge its colors and tones from a distance. There was nothing unsatisfactory, except the right hand; in my attempt to lower its value, I'd made it too red. I also decided that without a bit of pattern somewhere on the gown, the picture would remain visually uninteresting and rather vapid to anyone outside the subject's immediate family. (I suggest you, too, step back from your work at certain intervals. You probably will also discover things that escape the eye at close range.) I sponge off the hand (thanks to the impermeable underpainting I could do so without losing the drawing) and did it over. Then placing a sheet of tracing paper on the painting itself, I work out the design (A) for the collar and the cummerbund. I trace it onto the painting and render it in the same color as the gown— burnt sienna, green deep, orange, black, and white. Now compare the finished painting (B) with the original photograph. (This painting reproduced courtesy of Mrs. Dorothy Stalcup.)

Painting from Photographs

No one denies that there's hardly anything more stirring for the painter than to find himself (or herself) face to face with Nature. To be awed by her majesty, thrilled by her color, and challenged by her intricacies is the stuff that keeps the artist reaching for something better in every painting. However, if you're one of the thousands of chaps who must devote his daytimes to an alien task and are left with nothing but nights and weekends to practice his art, I suggest you take photographs and put them to use at every opportunity. Just remember: to be used creatively, photos must be reorganized subject to the laws of perspective, the dictates of composition, and the theories of color.

Landscape from a Black and White Photograph

If you want to do a painting in color, why complicate the problem by using a black and white photograph as a reference source? Because time and again you will come upon a photo that has excellent possibilities, even without color, and it would be a pity not to use it. Don't forget that, once upon a time, all photos were black and white, or sepia. The artists who used them—Delacroix, Courbet, Manet, Degas, Cézanne, Gauguin, Toulouse-Lautrec, just to mention a few—had to invent their own colors. My main reason for beginning this color section with a black and white photo as a reference is to give you free rein in the choice of your palette. You're free to use blue for a horse, purple for a tree, or green for a face—or you can stay with nature's own color scheme. I needn't tell you that the latter is my preference. I must also point out that even a good color photo isn't that true to nature. There are too many subtleties of hue detected by the artist's eye that still evade the best color processing.

1. The Black and White Photo. When working from the average color photo, your first problem to solve is composition. The actual "drawing" and color are, with some adjustments, already established for you. In this case, however, your challenge is to create a color scheme (with composition as a secondary problem) that will enhance and heighten the black and white statement of the photograph. This is certainly not a prepossessing photograph but there's something about its mood and simplicity that intrigued me enough to investigate its possibilities. I like very much the feeling of isolation and quiet conveyed by the boat. The bird on the mast is engaging, but to me this sort of thing doesn't belong in a painting. Perhaps it's just too cute. Now let's do some sketches.

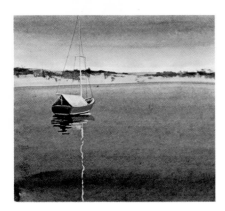

2. Exploratory Sketches.

Sketches are such fun and so quickly done that it's no trouble at all to dash off a few, and select whatever is most appropriate for a particular scene or situation. The sketches I've done here average 6″ × 8″ (15.2 cm × 20.3 cm), just big enough to let me work comfortably. This size also allows me to arrange with ease the elements in the horizontal composition I intend to use. I've done these sketches in gouache, or opaque watercolor, on scraps of paper or matboard. I visualize my composition simply, without anything detracting from the boat, to make its loneliness all the more poignant.

In heaven's name don't do this! (Sketch A). Don't stress the primary colors—red, yellow, and blue. This is the student's tendency, even when standing before — and supposedly observing —nature itself.

To establish this mood of quiet and solitude (B), I have to stay away from bright colors. For this sketch I use alizarin crimson, yellow ochre, burnt umber, and white, with the No. 20 flat sable, and a No. 3 watercolor brushes. However, the overall hue that I get in this sketch is a bit *too* brown.

The use of lilac here (C) as a pervading color suggests morning when everything is luminous and soft. "Pervading color," as the words suggest, is an overall hue that dominates the scene at a given moment. I use tempered red on the boat to conform with the pinkish cast of the pervading color. Now I know what to do— I'll combine the composition from sketch A with this color scheme.

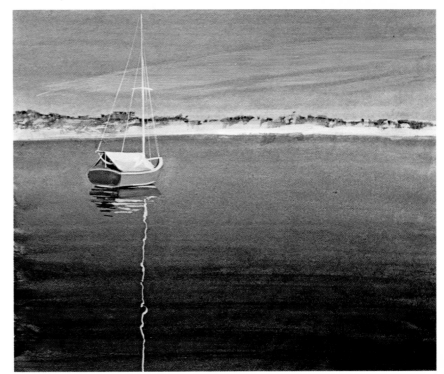

B

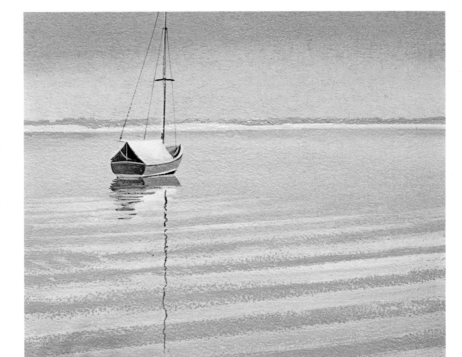

C

3. The First Underpainting.
Although there isn't room to
show you here, my next step is to
make a line drawing from my
preliminary sketches, incorporat-
ing the best elements of composi-
tion from them. Then, when I
have established the correct
shapes and proportions in the
line drawing, I trace it onto an
18″ × 24″ (45.7 cm × 61 cm)
illustration board, which will
serve as the surface of my
finished painting. I use a Bain-
bridge No. 80 medium-textured
surface, double thickness. The
step pictured here shows my first
underpainting on the board.
With a few drops of mineral
spirits and my painting knife, I
work Grumbacher's MG under-
painting white to a thinner con-
sistency. Notice that my under-
painting is so thin at this stage,
you can still see my penciled out-
lines. The only brush I use here
is a Simmons No. 11 flat bristle,
along with a paper palette.

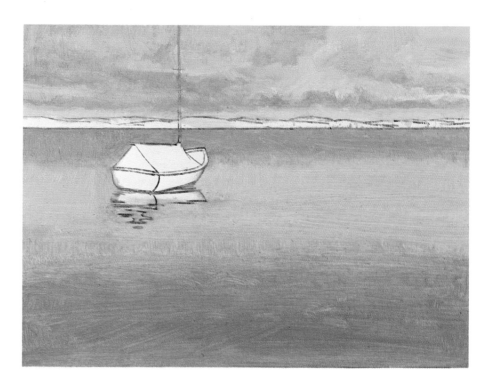

**4. The Underpainting Com-
pleted.** My palette consists
of alizarin crimson, yellow ochre,
French ultramarine blue, and
white. Now resting my hand on a
mahlstick, I indicate the boat
and its reflection using a smaller
bristle brush. I do the grass on
the dunes by patting a No. 4
bright bristle brush across the
horizon from left to right, trying
to vary the configurations to
make them interesting. When
the underpainting is finished, I
set the picture aside to dry, lean-
ing it face to the wall to avoid
dust. It takes about two days for
the underpainting to dry. After a
painting session, be sure to rinse
your brushes in turpentine or
mineral spirits, and then wash
them in tepid water, rubbing
them gently on a bar of Ivory
soap. Some artists prefer to rinse
and then dip them in lard oil. If
you prefer the latter method, be
sure to lay them down on a piece
of newspaper. When you use
them again (they'll stay pliable
for months), just rinse them vig-
orously in turps or spirits.

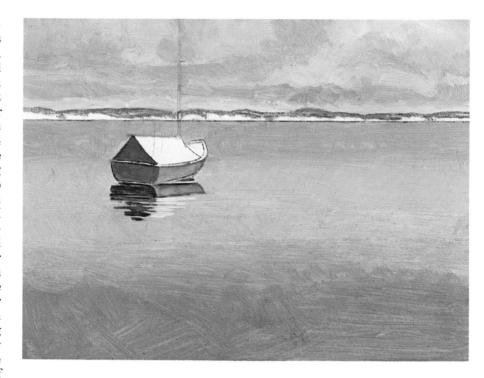

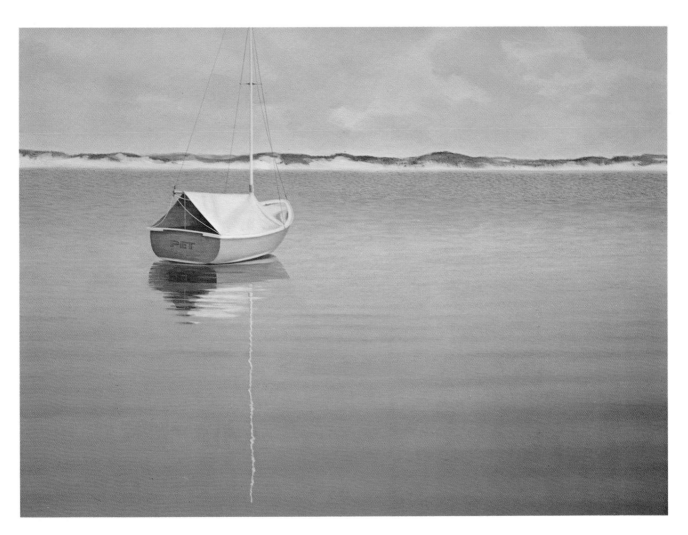

5. Adding Details. Now the fun begins. Everything previous to this final stage was only a preparation. I'll mention the brushes I pick as I need them. The colors I use in this final step are the same as in Step 4, but I've replaced the underpainting white with Winsor & Newton zinc white. Beginning at the top, using a No. 6 flat bristle, I paint the light areas of the clouds with medium-thick pigment, making them slightly larger than they will be, so that later I can trim them with their darker value. I take care to place a dark value in the sky behind the mast for contrast. Then with a No. 4 bright bristle, I again tap the grass configurations on the dunes. I switch to a No. 10 bristle bright and do the water, working it slightly into the boat. Now with a No. 1 watercolor brush I render the mast, the rigging, and smaller details on the boat. Using just the oil white on the mast, I discover it's not opaque enough to cover and execute the mast's sharp edges. So, I add casein white to the oil white and mix them together with my painting knife on the palette. This makes the white paint opaque and "long" so that it's easier to "pull" along the edges, and to render the thin white lines over the stern. I've always referred to this kind of overcast day as a "pearly day." This was my chance to capture it and get it out of my system. (This painting reproduced courtesy of Mr. and Mrs. Peter Thomas.)

Landscape with Simplified Details

Remember, whether using photos as reference sources or when working from life, nature will present her most complex and camouflaged aspect. Nature hardly ever provides the painter with a ready-made picture. You can, of course, delete the superfluous as you sketch, but the eye of the camera will set everything down indiscriminately. Always search a cluttered scene for the distillation, as it were, of the subject. It has been said that "less means more," and concerning painting, "less" means more clarity and a more forceful visual statement. In this demonstration I will be using egg tempera for the final painting.

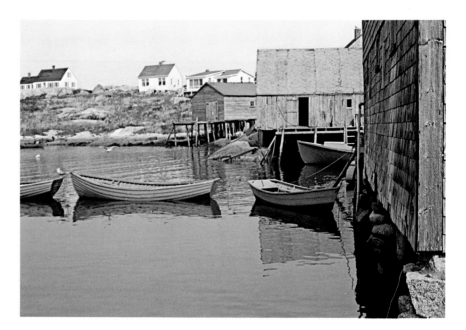

1. Good but Cluttered Photo. This is part of Peggy's Cove in Nova Scotia. There's such a profusion of subject matter in this area that the difficulty lies not in what to paint but in what to leave out. First, I put the slide in the Pana-Vue enlarger. With an office pencil, I indicate roughly the contours of the big shapes on scrap illustration board, searching for the right elements to include in my painting.

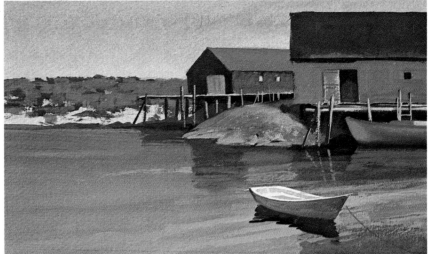

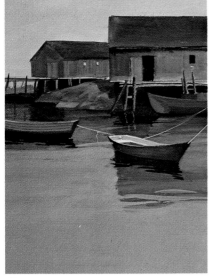

B

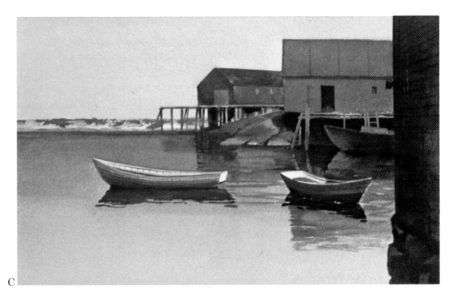

C

2. Sketches to Explore Simplification. When I've decided which elements I will use, I do some quick color sketches. As usual when sketching, I'm using my Pelikan watercolor box with Nos. 4 and 11 flat sable brushes, and also a No. 3 pointed watercolor brush for the smaller details. Check all the things I've eliminated from the photo to strengthen the composition of my sketches: note how a much simpler statement is far more eloquent than the clutter and confusion in the photograph. Another modification is that I've stressed the positive shapes of the ground and the buildings against the sky in darker values, to correct the washed-out and indeterminate shapes in the photo.

The keynote to Sketch A is the red boat, and the surrounding muted color serves to accentuate this bright spot. This sketch measures 5½″ × 9″ (14 cm × 22.9 cm). It could easily be trimmed one inch off the left without affecting composition, but I like the long horizontal shape.

In the next approach (B), I've concentrated on the barns and boats, and set them in a 8″ × 6″ (20.3 cm × 15.2 cm) vertical panel, with everything happening at the top. Now my colors are warm ochres and umbers with two blue boats to relieve the monochromatic scheme.

For my last sketch (C), I'm back to my favorite horizontal shape (5½″ × 9″). This is the one I'll paint; it has the luminosity I'm striving for. The dark shape on the right adds depth to the scene, a lower shoreline clarifies the barn and the dock, and the additional boat provides a better balance of positive shapes.

3. The Line Drawing. At this point, I begin my line drawing, and do it quickly. Using the squaring-up method, I enlarge the elements of my sketch to an area 12″ × 20″ (30.5 cm × 50.8 cm). Then I trace every line of my pencil drawing to a piece of Superior medium-textured, double-thick illustration board, which will be the surface of my finished painting.

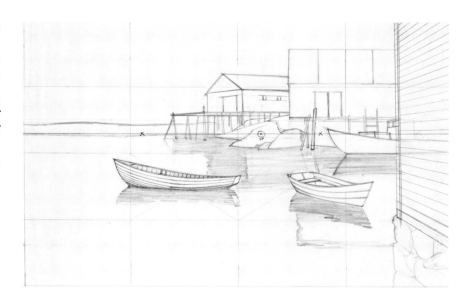

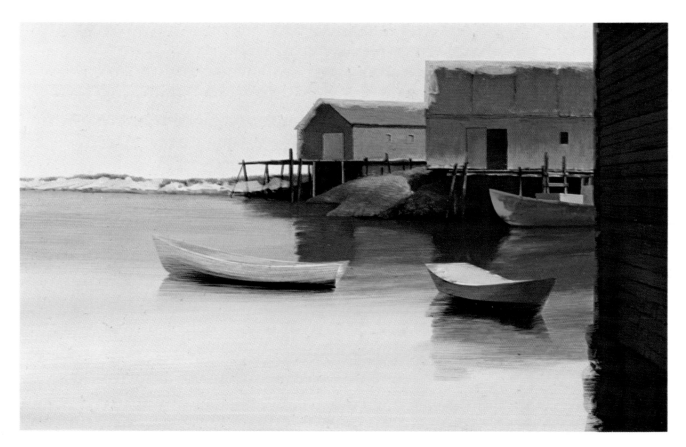

4. The Underpainting. After the drawing is traced to the board, I go back and check my color sketch. My egg tempera palette will be alizarin crimson, vermilion, yellow ochre, thalo blue, viridian, ivory black, and titanium white. My brushes are Winsor & Newton Nos. 3, 5, and 8 pointed sables. I first paint the shingled wall on the far right to establish the darkest tone so I can then key the light and intermediate values in the rest of the painting. I use the largest brush, naturally, on the big areas of the sky and the water. The brush is only half-charged with very thin pigment to convey the "smoothness" of both sky and water. Less diluted, but still thin, is the paint on the buildings and the boats. The only places where I use the egg tempera straight from my mixing dishes are the rocks under the boathouses, and in the foundation at the lower right corner of the picture.

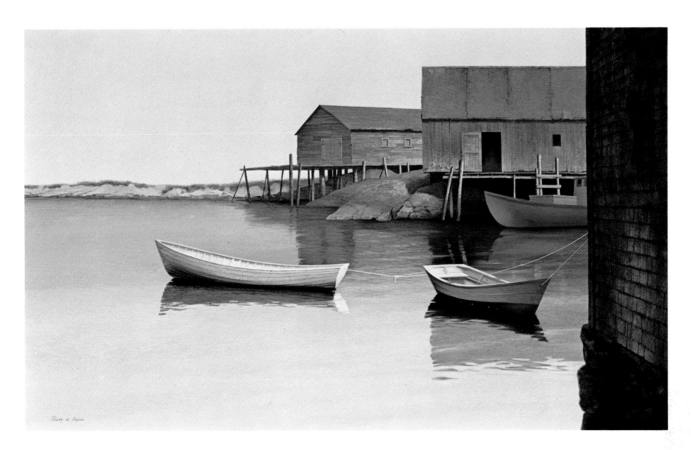

5. Final Details. When finishing, I work my way forward. Here, I do the sky, the shoreline, the buildings, the water, the boats, and finally the shingled wall on the right, in that order. Until now, I worked without any support for my hands, and without touching the painting. However, the details—the ribbing on the boats and the lines securing them, the piles, the hinges and the windows on the far building, the shingles in the foreground—are all too small and meticulous to do with my hand in mid-air. So, I rest it on a mahlstick. When using transparent or opaque watercolor or acrylic, my hand can rest on a piece of paper placed over the surface of the painting I am working on. But egg tempera is a delicate medium that might smudge, especially the light areas. When you take an egg tempera painting to the framer, caution him, since the majority of artists don't work in egg tempera, and he may not be aware of the careful handling a painting in this medium requires. (This painting reproduced courtesy of Mr. and Mrs. Clyde C. Roth.)

Landscape with Fleeting Lighting Effects

As I mentioned before, when my friends learned that this book dealt with painting from photographs, I was deluged with photos of wives and children, cats and dogs and birds, beaches, boats, trees, churches, and room interiors; all the things that people photograph for fun or as mementos. I was delighted. It proves my point that there's enough material—and photographs—in every home to do a hundred paintings, and I intend to show you how.

Photographs can be especially useful when you want to capture a fleeting effect of nature: cloud formation, a sunrise, or, as in this demonstration, a sunset. This photo, given to me, caught my eye. It shows one of the fleeting moments that I was preparing to snap myself with my faithful Instamatic. I borrowed it and put it in my Pana-Vue, which enlarges a 35mm slide to 2¼″ × 2¼″, (5.7 cm × 5.7 cm), to work out a sketch or two. But even as I went through these preparations, I had the feeling that I could find, in nature or another photograph, a more glorious sunset than this. Actually, what I really wanted was a sunrise—they can be breathtakingly beautiful. But every time I made the heroic sacrifice and rose at dawn, I found nothing but a wan and sickly light not worth recording.

Slide with fleeting light effect.

1. New Start with a Different Photo. All right, let's have another go at it. There were no sunsets worthy of the name for several days, and when one came along, my photographer was in Boston. I still didn't have the foggiest idea about how to operate the Nikon I'd purchased especially to do this book, so there was nothing to do but keep my Instamatic at hand. After several "colorless sinkings," this happened. A professional photographer would have caught the beauty I'd seen, but my photo seemed to capture nothing worthy of paint. Yet, studying it closely, I began to find certain features worth developing. I liked the shape of the clouds, and the vibrant and pulsating glow behind them that was on the verge of fading away momentarily. I also like the subtlety of the yellows, pinks, and violets close to the horizon. The foreground, as you see, was meaningless but the sky had possibilities.

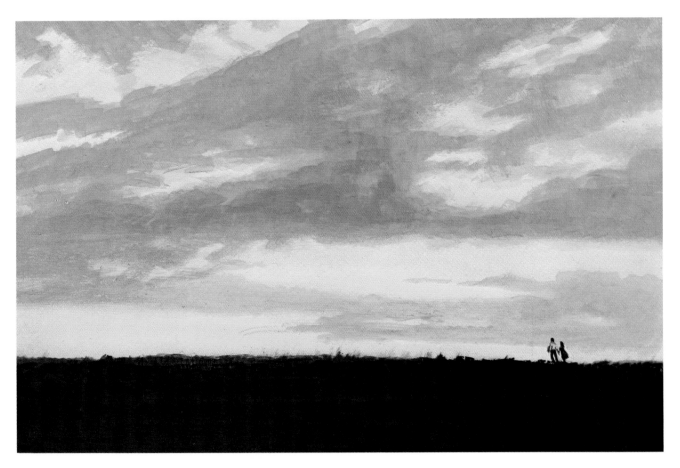

2. Preliminary Sketch. To emphasize the peaceful mood I want in this painting, I've replaced the active diagonals in the photo with a long horizontal for the ground. To reinforce the vastness of the sky and give scale to the land, I've introduced the small figures on the horizon. These qualities can be already felt, even though the sketch is only 7½″ × 11¾″ (18.2 cm × 30 cm). I use opaque watercolors from the Pelikan box. My palette consists of alizarin crimson, turquoise blue, cobalt blue, light yellow, burnt umber, and a jar of Artone white. I give the sky its pastel bands from edge to edge, beginning at the top with a pink one. Mixing on the tray the color for each band and blending, horizontally, wet-into-wet, I continue down until I get to the yellow-orange at the horizon.

3. First Lay-in. Relying on my sketch for both composition and color, I begin my painting directly on a Bainbridge No. 80 illustration board 12½″ × 20″ (31.5 cm × 51 cm) without tracing any drawing. I just indicate very lightly with an office pencil the main configurations of the clouds, then start my lay-in with very diluted egg tempera. My colors are alizarin crimson, cadmium yellow light, yellow ochre, Thalo blue, ivory black, and titanium white. This time, I mix the colors for the sky and apply them directly in their individual positions, instead of running the bands of color all the way across as I did in the sketch. I do the bands larger than they really are, so they can later be trimmed and shaped by the overlapping clouds. For the latter, I prepare thin mixtures of light, medium, and dark gray values in three individual dishes, and I apply them freehand with scantily charged watercolor brushes, Nos. 3, 5, and 7.

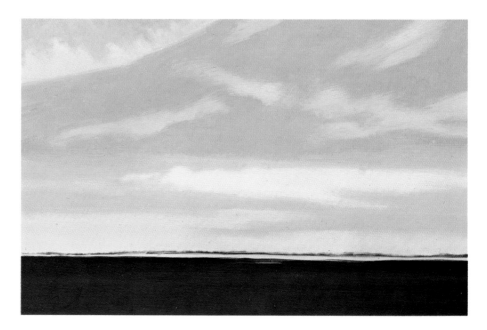

4. Refinements and Details. This is the painting at the halfway mark. The underpainting for the ground is only a dark band done with a No. 20 flat sable. I can use it as a tonal reference point as I apply the lighter values in the sky. Notice I've worked the sky into the horizon, and then with a No. 3 brush, I regain the edge of the grassy ground. As I work the clouds down to the horizon I start dipping into the crimson and the yellows, along with the grays I used for the clouds.

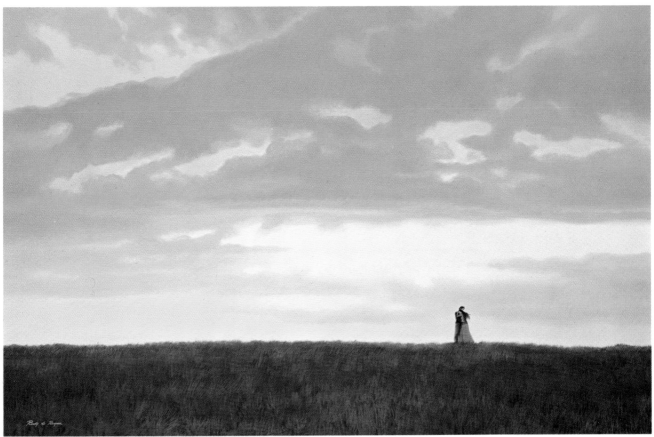

A

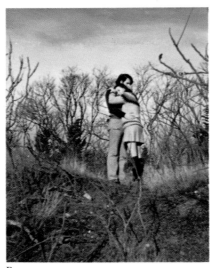

B

5. Final Details. I was displeased with the figures in my preliminary sketch. As I looked at my almost completed painting (A), I realized that "walking into the sunset" had negative connotations—a legacy of Hollywood, no doubt. But, friends, bless them, are always ready to pose. Jon and Diane, knowing the area (I've written this book while at Cape Cod) led me to a field that resembled the one I'd painted. I decided to have the couple embracing. When I saw the print (B), I knew the addition of these figures would do it! I added the figures to the horizon with a No. 0 and No. 00 brush. (This painting reproduced courtesy of Mr. and Mrs. Jonathan Fitch.)

Night Landscape from Daylight Photograph

How can you paint a landscape at night, when there's no light to see what you're doing? Using photos as your reference source can really help you. In this demonstration, I'll show you how to convert a daylight photograph to a night scene. My approach is to match the colors in the daylight shots, then lower their values and intensities by adding the necessary complementary colors or black. I was planning to do a nocturne of Sandy Neck Beach for this project when I got a phone call from friends in Connecticut who wanted a painting of their home because they were moving to New Hampshire. "Marvelous subject to paint," was my reaction, "maybe I can use it in the book." Well, I couldn't believe my ears when Peter added "Do you think it would be too stagey? But I want it in the moonlight."

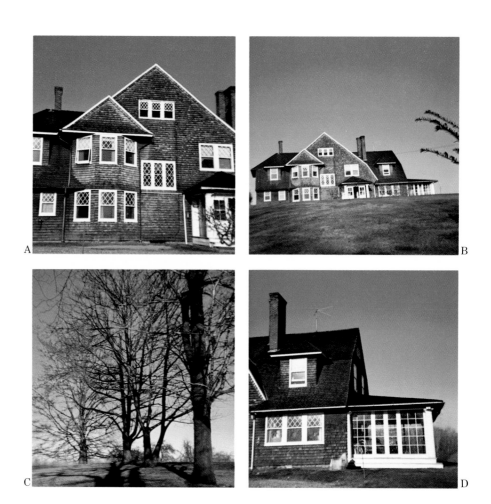

1. The Photographs. Using my Instamatic, I shot the house from one end to the other, getting as close as possible for details (A). Then I drew back far enough for a shot of the entire silhouette (B). I didn't really know if I'd need trees in the painting (C), but I've learned it's always better to have more material than you need, than to stop work and shoot again after the painting is begun. I took several photos altogether, from which I chose one more (D) that gave me a slightly different and interesting view of the house. For easy reference, I taped the four photos in sequence onto a piece of matboard.

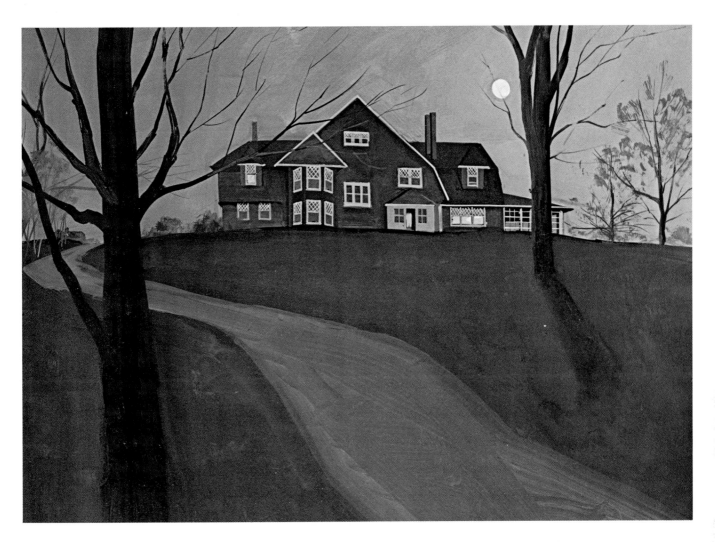

2. The Color Sketch. More than ever I needed a sketch to solve the problems of composition and, especially, color. I roamed the grounds of the house by night. I tried sketching from the car, but the light there was too warm and too dim, so after close observation of the trees, the road, grassy slopes, and lighted windows, I rushed home and immediately set down the effects I had seen. When I had enough information, I consulted the Instamatic shot of the entire house, made a rough pencil enlargement by eye on tracing paper, and then placed a sheet of acetate over it. This way I could easily wipe off anything I didn't like and start again without disturbing the drawing. I used Marabu opaque watercolors, and my palette was ultramarine blue, cobalt blue, raw umber, burnt umber, yellow ochre, light yellow, blue-green, black, and the jar of Artone white. Now, taking up a fresh sheet of tracing paper, I enlarge the sketch by eye to 22″ × 26″ (55.9 cm × 66 cm).

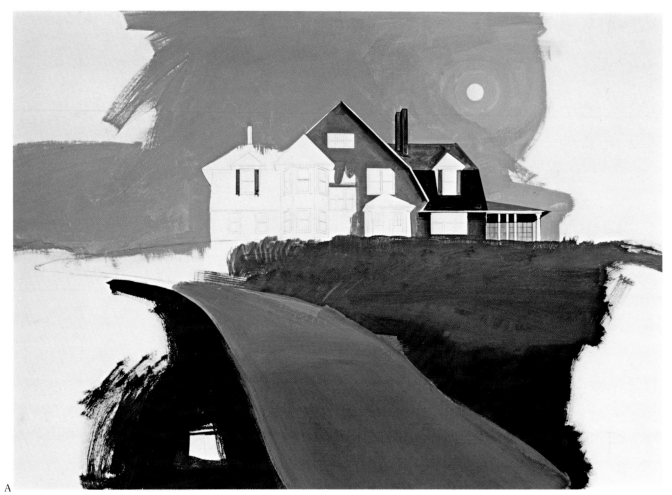

A

B

1 2

3 4

3. Beginning the Underpainting. After tracing the enlarged drawing with a very dark line to a 26″ × 30″ (66 cm × 76.2 cm) piece of Superior medium-texture illustration board, I begin the lay-in (A) with Winsor & Newton Designers' Gouache (opaque watercolors): burnt sienna, yellow ochre, brilliant yellow, burnt umber, ultramarine and cobalt blue, viridian, ivory black, and white from the Artone jar. I use the No. 20 flat sable on the sky and the ground, and Nos. 3 and 5 watercolor brushes on the house. My paint is very thin—as it should always be for the underpainting, no matter what the medium. There's no attempt at defining detail; my purpose is to cover the white board as quickly as possible. In the color chart (B), you can see how I transcribe the bright daylight colors (top) into the muted colors of night (bottom). The first swatch on the left represents the general color of the shingles. The daylight color consists of burnt sienna, green deep, and white; to this green, I add black and ultramarine for the night value. The second swatch—burnt sienna and white—shows the red of the chimneys; I add black and ultramarine blue to this to create the night value. The third swatch represents the green of the grass, a mixture of medium green and orange. Adding green deep, burnt sienna, and ultramarine blue deepens the grass color to its night value. The fourth swatch represents the blue of the sky—white with a touch of cobalt blue; to lower its value, I add ultramarine blue, yellow ochre, and black. For the white trim of the windows I mix ultramarine, burnt sienna, and white. The lightened windows consist of brilliant yellow and white, and the moon is white with a whisper of viridian and cobalt blue.

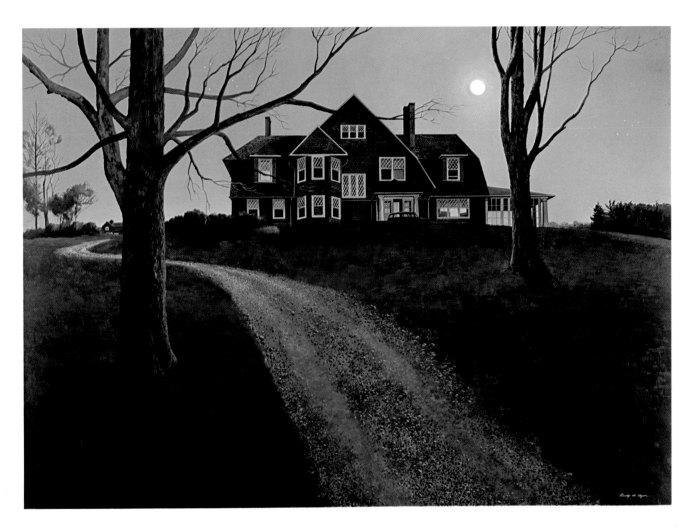

4. Painting Main Shapes and Finishing Touches. I did a few sketches of trees, based on the photo you saw in Step 1. Now I trace the trunks and main branches of the trees onto the painting and use black, alizarin crimson, and ultramarine blue with touches of white. Because I'm using opaque watercolor, I can place a piece of paper under my hand and rest it right on the painting without fear of harming it. I do all the straight edges and lines on the house using the ruling method. When everything behind the trees is done, I finish them to the last twig with a No. 2 pointed brush. Then, with the same brush, I define the gravel on the road, and give the grass its last touches. Notice that I've eliminated the trees on the far right and replaced them with a group of evergreens so that the eye can glide smoothly from the top of the porch, to the top of the trees, and on to the border. Always be aware of the rhythm between one shape and another. I still have a nagging feeling that even though the slope up to the house is made clear by the shadow in the foreground—and by the road curving up—I feel I can make it "read" better. It's for this reason that I place the car in front of the door, with only the top showing. (This painting reproduced courtesy of Mr. and Mrs. Peter Thomas.)

Seascape Modifying the Color of Original Photograph

When checking a friend's collection of photographs for possible subject material, I wasn't at all surprised that the majority had outrageous color. I don't know why, but the blues, especially, in most color snapshots are so strong and so harsh that they knock you off your chair. It would be a pity, however, not to use a photograph that has all the attributes of a good painting, except color, because it is an element that you can so easily correct in your final painting.

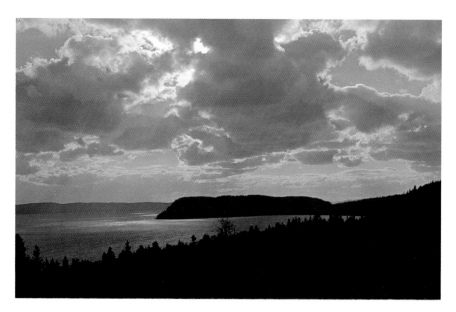

1. Slide with Very Bad Color. Here's a good example of the overwhelming blue I mentioned a moment ago. In every other respect this photo is good reference material for a landscape. I like the light-fringed shape and position of the clouds, the low horizon, and the "spotlight" effect on the shimmering water. True, the foreground competes with the sky for attention, so I'll just remove it.

2. Sketch to Correct Color. Following my usual procedure of slipping the slide in the Pana-Vue enlarger, I begin my color sketch. For this small 5″ × 6½″ (12.7 cm × 16.5 cm) sketch, I use watercolor brushes Nos. 3 and 5. As in the preceding project, I use Winsor & Newton opaque watercolors and paint the sky first, starting at the top with cobalt blue and white, and then adding more white and turquoise as I near the horizon. Finally, over the graded sky I do the clouds. I waited for the right day to do this, when the sky was partly cloudy, so I could easily check their true color. The gray interiors of the clouds consist of ultramarine blue, Indian red, yellow ochre, and white, while their sparkling contours are mostly white tempered with alizarin crimson, lemon yellow, and viridian. A far cry from the blue in the photograph!

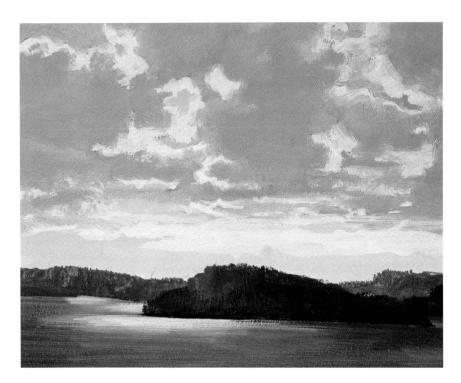

3. Major Shapes Painted In. Following my usual procedure, I enlarge my color sketch using the squaring-up method. The enlarged drawing measures 22″ × 28½″ (55.9 cm × 72 cm). After I've transferred it to an 30″ × 40″ (76.2 cm × 101.6 cm) Crescent medium-textured illustration board, which I will later trim to the drawing's dimensions, I begin to paint. I mix in my china dishes the following egg tempera colors: Mars red, yellow ochre, cadmium yellow light, Thalo blue, viridian, and titanium white. I've layed in the clouds with the red, the yellow ochre, and the blue with much more white, and using a No. 20 flat sable brush. For the sky peeking through the clouds, I use white with some blue and switch to Nos. 5 and 8 brushes. As you can see, I'm not yet concerned with softness of the edges.

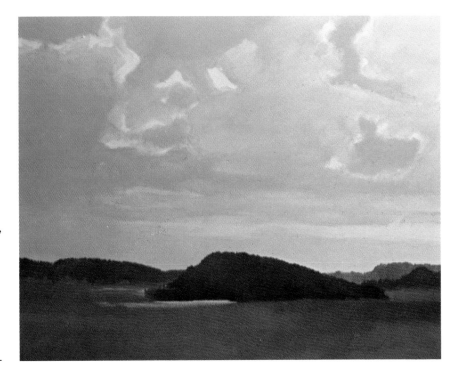

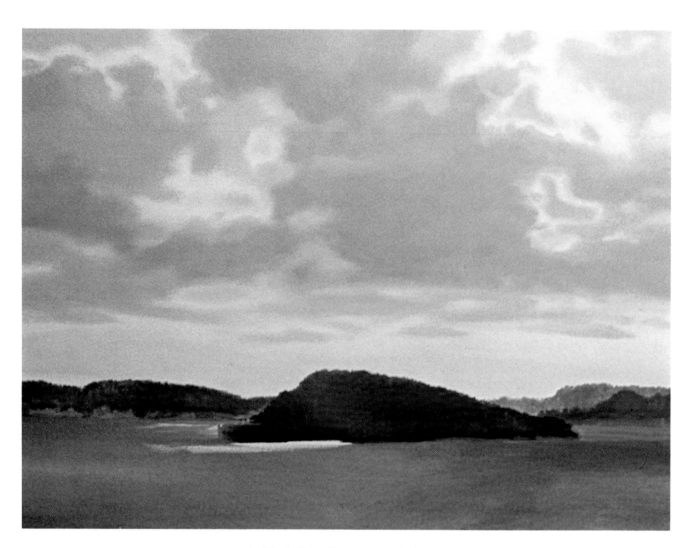

4. Modeling Forms and Softening Edges. Besides the colors I've mentioned, I have now on my butcher's tray three additional dishes with the light, medium, and dark grays, which I use for the modeling of the clouds. The grays are a mixture of Mars red, yellow ochre, and the Thalo blue with varying amounts of white in each dish to get the three required values. It's much easier to work this way than to mix the tones as I paint. I'm also beginning to soften cloud edges with white and a whisper of cadmium yellow light.

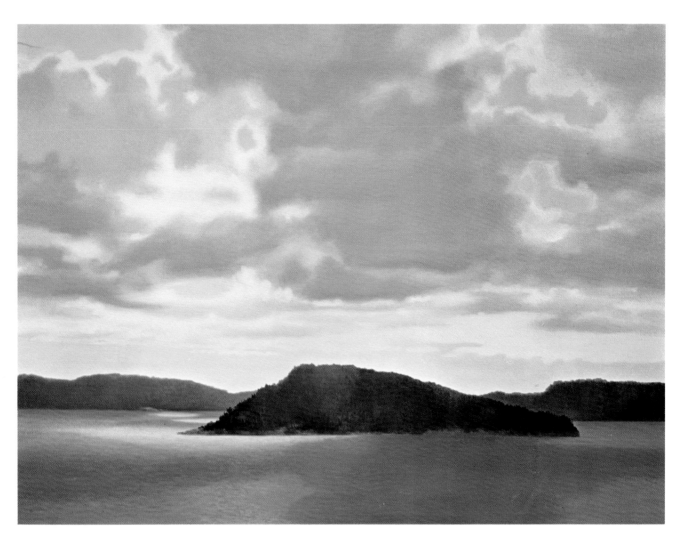

5. Adding Details. After finishing the sky, I move down to the islands, add ivory black to the palette, and exchange the Thalo for ultramarine blue. But now instead of working freehand—as I did in Step 4—I rest my hand on a mahlstick to define the edges of the islands and to render the ripples on the water. I've now discarded the No. 8 brush, and finish the painting with only the Nos. 3 and 5 pointed sables.

PROJECT 17

Seascape with Rapidly Changing Details

When I came to this assignment in my outline for the book, I danced a jig for joy because Maine has always been one of my favorite sketching grounds. This time, however, my purpose was not to sketch but to "freeze" with a camera the everchanging aspects of the restless sea: the rolling wave, the dripping rock, the foamy splash, the heaving, ebbing water with its lacy spume, etc. Here the camera can best serve the painter, capturing for him mercurial subjects like these that never "hold a pose."

I should mention that the accepted and popular support for oils is canvas, not illustration board, which I use in this demonstration. I prefer the latter because I don't really like the resiliency of canvas when I work. I could, of course, glue a piece of canvas to a board, but I'm too lazy. The canvas boards that you can buy are of such inferior quality that it's better to avoid them altogether.

A

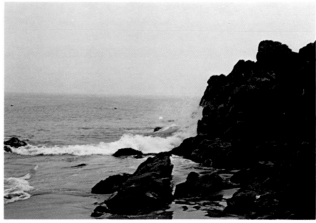

B

1. Selecting Elements. Selecting the features that you like from a snapshot and integrating them in your final composition is one of the advantages of working from photos. I will use the crashing wave (A), the cliff (B), and the reddish rocks (C) for my foreground.

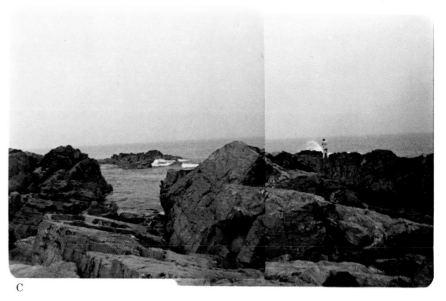

C

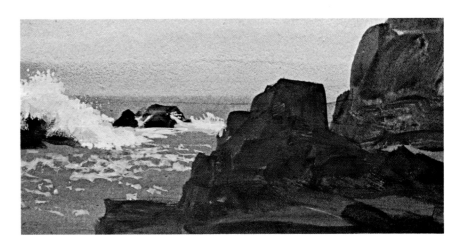

2. Preliminary Sketch. Once I've selected the parts of each photo that I like, I do a sketch that incorporates all the individual parts into one unified composition. Since I'm not interested at this point in color accuracy, I've used mostly umber and burnt sienna opaque watercolors. (I often do my preliminary sketches in opaques, because I'm so comfortable with them and they respond to changes readily.) Although I don't have room to show it here, my next step would be to make a line drawing from this sketch, enlarging it to 14″ × 29½″ (35.6 cm × 74 cm), the size of my final painting.

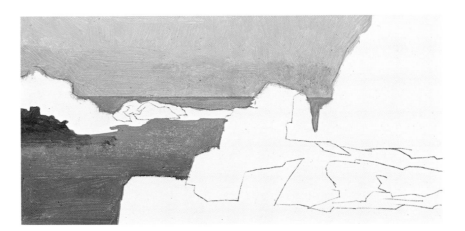

3. First Lay-in of Paint. Once my line drawing is transferred to a 20″ × 30″ (50.8 cm × 76.2 cm) Bainbridge cold-pressed illustration board, I can begin using oils. With my painting knife, I knead Grumbacher underpainting white and a spot of turps on the palette to make the paint thinner. I find this more practical than thinning the thick white paint as I work, especially when underpainting. My palette for this beginning stage is Winsor & Newton raw umber, yellow ochre, and French ultramarine. I paint on the bare board, because I don't like the slick surface I get when the drawing is isolated with clear lacquer, shellac, or varnish. Sometimes I squeeze the oil paint on a piece of blotting paper to extract the oil and reduce the sticky and slippery quality of the medium. Doing this produces a mat surface when the oil dries. Some artists add oil to their medium to retard the drying period of the paint even longer and to create added gloss to the painting. Here are the first two areas I've painted, in thin color, done with Simmons bristle flats Nos. 5 and 11.

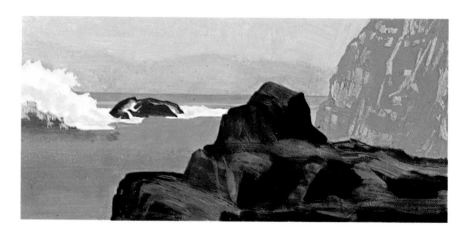

4. Main Shapes Painted In. Here I lay in the general configurations of the rocky areas with the same bristle brushes and the same colors I used in the preceding step, but with a thicker consistency paint. To develop the rougher character of the cliff, I pick up a painting knife and scrape into the paint with its edge. Then, turning to the broad side of the blade, I pat paint on both the cliff and on the foreground rock. When I finish the underpainting on all the areas, I lean the panel face to the wall; this reduces dust collection on the surface. While my underpainting dries, I'll go out and sketch an old barn I've wanted to get to for a long time.

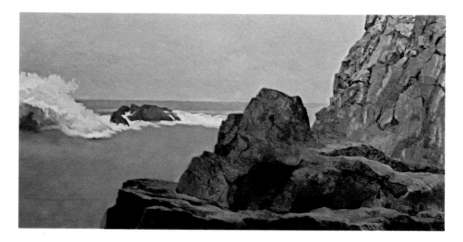

5. Beginning to Define. When the underpainting is dry, the first thing I do is study the ridges left in the paint by my painting knife. If they destroy the plane of a form, or play havoc with a shadow area, I scrape them off with the edge of my painting knife. Naturally I don't touch the ones that strengthen an edge or heighten a texture. Now that I've begun to paint, I add burnt sienna to my palette of raw umber, yellow ochre, and ultramarine, and replace my Grumbacher underpainting white with Winsor & Newton zinc white. Notice that instead of working my way forward as I usually do, I've chosen to develop the foreground still further, so that I can key in the correct color and value of the sky and the sea to these two large foreground shapes. To get closer to the color in my preliminary sketch, I glaze (with the No. 20 flat sable) the foreground rock using a thin solution of turps, a spot of retouching varnish, and just a bit of burnt sienna.

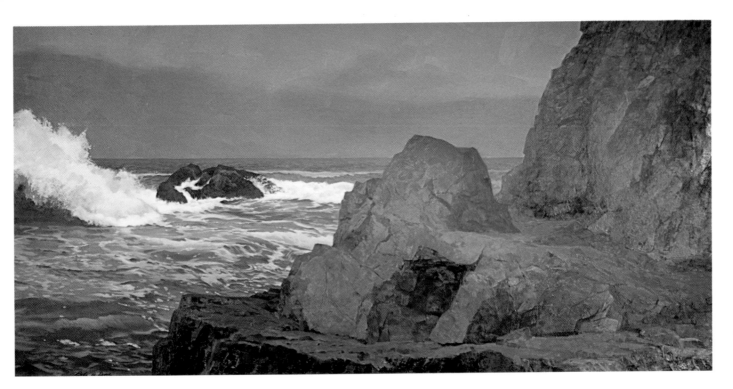

6. Finishing Up. I pick up a No. 3 pointed sable to stipple the contour of the splash and to render the spume in the foreground. The sky and the cloud bank are done with bristle flats Nos. 6 and 10, using raw umber, ultramarine, viridian, and white. I work this tone slightly into the cliff, the horizon, and the foreground. Then I go over the frothy contour of the wave, again stippling with my No. 3 sable, and move on to the light, lacy pattern left on the water by the previous wave. I finish the sea completely and then go over to the gray cliff, where I scumble a whisper of burnt sienna to better integrate it with the reddish rock. I do the foreground last and regain its contour that was slightly overlapped by the cliff and the sea. (This painting reproduced courtesy of Mr. John F. Gardner.)

PROJECT 18

Portrait from Photographs and Sketches

I set out to do this job with all the conventional trappings of portrait painting. First, I study and observe the person, not just physical appearance, but, more importantly, the particular personality traits unique to the subject. During this period of examination, several incidents demonstrated to me that Diane was the most tenderhearted, benovolent, and unassuming person I had ever observed. I resolved that these were the qualities I should clearly convey in the portrait.

1. The Rough Sketches. I begin with rough sketches because it's the most practical approach to finding a pose and because I'd like to make it clear that there's no rigid or set way to start a piece of work. In these sketches, I explore poses and gestures that would best bring out Diane's personality. Notice that, rough as they are, the sketches give me a clear idea of what to consider as well as what to avoid—which is just as important. Notice, too, that I'm not yet concerned with accurate drawing or likeness. I've numbered my sketches 1, 2, and 3, in order of preference. I like the composition and tonal scheme of sketch 4, but the gesture is too worldly and sophisticated for the subject.

A

B

2. The Photos. Perhaps to prove anew that the best-laid plans of mice and men can go awry, none of the sketches was used! When the lights had been set up and the photographer was attaching the camera to a tripod, my model walked over and looked out the window. "Stay as you are, don't move!" I said—not taking any chances of losing the ingenuous and artless gesture that so clearly conveyed Diane's character and personality—and this is a photograph (A) of that pose. Of course all my preconceived ideas had to be discarded, but I won't throw away the sketches because I still like sketch 4 very much. All I need now is an elegant and sophisticated woman on the market for a portrait! For the indoor props, I chose a table and jug, shown in this photo (B).

3. Sketch for Composition and Tone. I begin this 7⅛″ × 11¼″ (18 cm × 27 cm) sketch with an office pencil on a No. 524 Aquabee tracing pad. The view through the window is just imaginary; I'll snap something later with my Instamatic. I still don't know what the bouquet will be, but for compositional reasons, this is the shape it must have.

4. The Underpainting. After constructing a 19" × 30" (48.3 cm × 76.2 cm) grid on a 22" × 30" (55.9 cm × 76.2 cm) Bainbridge double-thick illustration board, I slip the slide from Step 2 into the projector and trace the line drawing right onto the board. I refer back to the grid over the sketch for exact scale and placement of the props. Using the sketch as a guide for the tonal scheme, I start the painting with washes of black acrylic. I use Mars black and water only, with a No. 6 Simmons bristle flat, and a No. 3 Winsor & Newton watercolor brush. I place the table and the vase in perspective with Diane's photograph.

5. Color Washes Over the Black Underpainting. Now I add burnt umber, Grumbacher red, yellow ochre, and ultramarine blue to the black, applying the paint in very thin washes. The new arrangement caused by inclusion of this snow scene in the window works better compositionally, because the directional thrusts now force the eye to the right—beyond the drapery to where the feeder supposedly is. Shifting my attention indoors, I paint the wall with a mixture of yellow ochre and black, applied with a No. 14 flat sable. The flesh areas consist of burnt umber, Grumbacher red, yellow ochre, and ultramarine blue, in varying amounts to cool, to warm, or to deepen a tone.

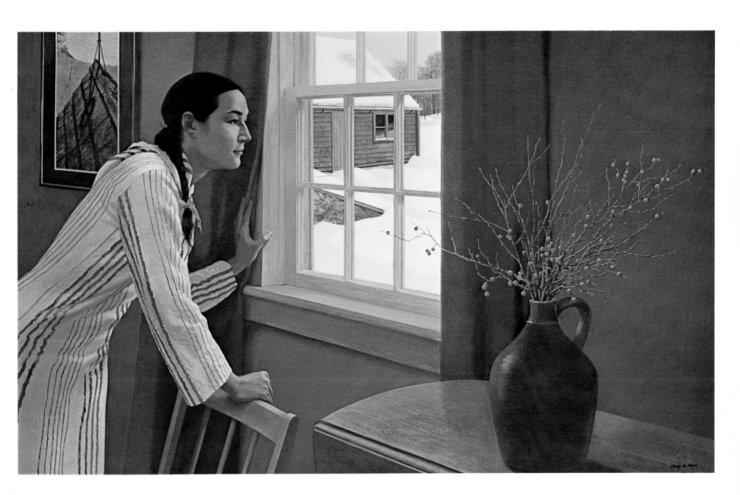

6. Finishing the Painting. Now I add titanium white to the palette and begin painting every area in the picture, including the snow, in body color; using this, instead of washes with no white, I can get exactly the color, value, and *texture* I want. With the tentative value and color already worked out in Step 5, I now just mix thicker pigment to match the curtains, the flesh areas, and the walls. Every value and every color must be exactly right so that the viewer is led to Diane's head without any distractions. Here are some of the things that I do to accomplish this. I subdue the red on the curtains and make it deeper in value for greater contrast to the lights on her face. The braid of her hair has been lengthened and adorned with a bright ribbon to pull the eye to this area. As if to prove the point of this book, my model was called away to Washington, D.C. on an emergency. Had it not been for the photographs of her, I would have had to stop work just when I was getting all wrapped up in it. (This painting reproduced courtesy of Mr. and Mrs. Jonathan Fitch.)

Still Life from Color Slides

When I walked up the stairs and into my friend Winnie's studio, I resolved then and there to paint it, the sooner the better. What first impelled me to paint this interior was the exciting arrangement of the timbers, and the color and texture of the chimney and plaster ceiling. It seemed to me that the addition of a bright spot — flowers — would complement the scene perfectly. So I put some red geraniums in a pitcher and took a snapshot. With this photo for reference, I could take as much time as I needed for my painting. Real flowers would have faded and died long before it was completed.

Original snapshot for reference.

1. The Sketch. This is the rough sketch I did immediately to see how the view would compose. I used an Aquabee tracing pad No. 525, 16″ × 20″ (40.6 cm × 50.8 cm), and an office pencil, drawing directly from life. There were no flowers in the brass pitcher at first, but I indicated some, because from the very beginning I visualized a bright spot here. When finished, I fixed the sketch so it wouldn't smudge as I handled it in the steps that follow. There's a fixative now put out by Eagle that doesn't have those ghastly fumes. Try it.

2. Separating the Linear Structure. Having settled the question of composition and tone, I now look to the correct construction of the elements in line. I place another sheet of tracing paper over the sketch so I'm not distracted by the tone in the sketch while working on the linear aspects of the elements. I tentatively set the eye level at point a , and I retain the border from the original sketch, which measures 9½″ × 14″ (24.1 cm × 35.6 cm). Although there's no room to show you here, I'll "true-up" my perspective with still another sheet of tracing paper placed over my line drawing. When I'm satisfied with its accuracy I'll transfer my drawing to my painting surface.

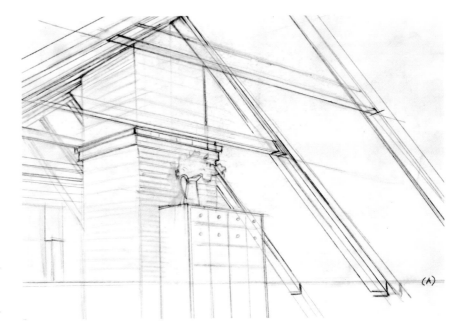

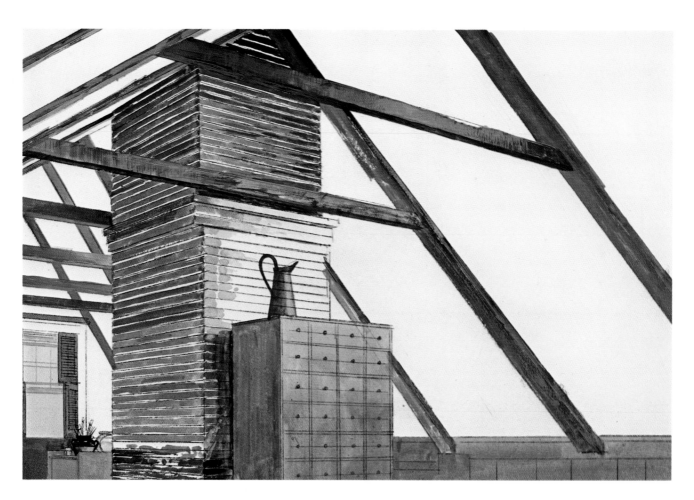

3. Main Shapes Painted In. I trace the line drawing on a piece of double thick, rough surface illustration board. (It goes without saying that I chose a rough surface because rough textures prevail in the painting.) Then I moisten the following opaque watercolors in my Pelikan set: blue-green, Payne's grey, cobalt blue, ultramarine blue, black, orange, vermilion, carmine, Indian red, Venetian red, yellow ochre, raw umber, and burnt umber. I apply the paint very thinly with quick strokes, using the broad side of a No. 8 flat sable on the beams, and Nos. 5 and 3 watercolor brushes on the bricks. Quick strokes bring out the rough surface of the paper.

B

A

4. Using Color Slides for Reference. In the closeup (A), you can see the flowers I put in the pitcher. To render the flowers, I place a piece of tracing paper over the spot in my painting where the flowers should go, and block them in with an office pencil. No details, only the overall contour of the mass, then I subdivide it into the smaller shapes formed by the flowers and the leaves, modifying them a bit until they work in harmony with the vessel. I place crumpled newspapers in the pitcher to simulate their bulk and render the shadow cast by it. Because I was skeptical as to whether the camera would be faithful to the color of the leaves and flowers, I also did a color sketch (B) to register the bouquet's actual colors. To match the brilliance of the geraniums, I switched from watercolor to acrylic paint (Liquitex acra red.) For the lighter values on the petals, I used Rich Art white poster paint, and for their darker tones, I mixed burnt umber and a touch of blue-green into the acrylic acra red. All the greens of the foliage are done in Pelikan opaque watercolors. Notice the difference in color — the reds are yellower and the greens darker in the slide (A) than in my sketch (B).

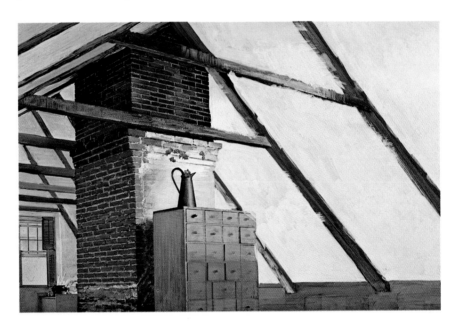

5. Main Shapes Continued. On checking the color and detail of the cabinet, I discover that it has four rows of four drawers, and two rows of three drawers. This is easily corrected since I'm using opaque watercolor—white, yellow ochre, and a whisper of blue-green. I add the knobs in burnt and raw umbers. I stroke in the plaster ceiling with a No. 20 flat sable, using cobalt blue, raw umber, yellow ochre, and much white.

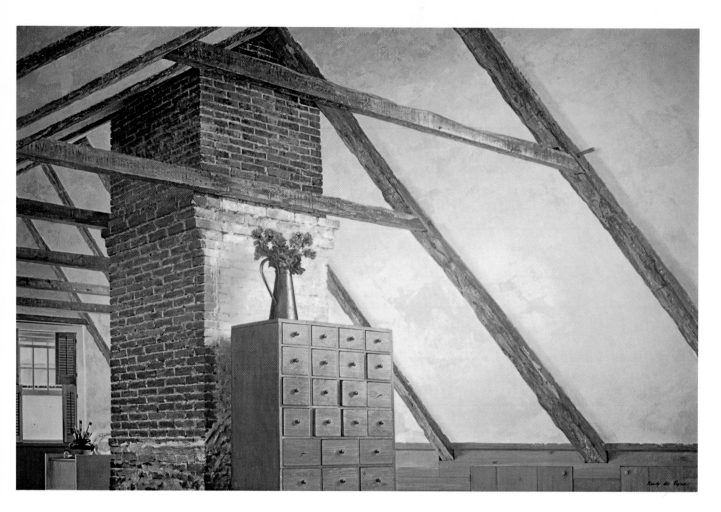

6. The Finish. Even though I was pleased with the cool colors (cobalt blue and white with a touch of raw umber), and the warm ones (white, raw umber, and a touch of yellow ochre) on the ceiling, I still feel that the painting needs more texture. I reapply the same colors mentioned with my painting knife to give a more interesting surface. Then I move over to the beams and restore their contours with a No. 5 watercolor brush. As is always the case when a painting is near completion, you can work anywhere the mood strikes, because it's only a matter of rendering details. I paint the brushes in the pot, then finish the window, the shutters, the taboret, and the wood panel behind it. I give final touches to the pitcher, using blue-green, burnt umber, ultramarine blue, yellow ochre, and white with a No. 2 watercolor brush. The last thing I do is the mortar on the chimney.

Experimenting with Photographs

I've always believed that it is a poor teacher who is not eventually excelled by his student, and I'm still confident that none of you will prove me wrong. The premise of this book is that photographs can be used as an aid to creative painting, not just as material to copy. After you've mastered all the methods of enlarging a photo, selecting and composing various elements from a photo, and painting from a photo, I'd like you to try and experiment with new ways to use photographs. Start with the three following projects—photographs from television, abstract design from photographs, and stop-action photographs—and then proceed from there. There's a school of thought which claims that Art itself sires other Art; the dancer, the musician, and the writer all inspire the painter, and they in turn are stimulated by his work. If so, then let the art of photography refresh your concepts and intensify your imagery through constant experimentation.

Photographs from Television

Perhaps it'll surprise you to know that artists use the television as a source of information for their work. I have friends who listen to it as they paint, others who sketch from it, and still others who set up a camera and photograph whatever scenes may be of future use. Another interesting approach is to order photostatic enlargements of photographs taken from the television. I know a chap who does this quite often. After mounting the stats on cardboard, he paints right over them in oil or acrylic, accentuating what he wants, veiling some parts with glazes, and completely eliminating others to the point that sometimes he ends up with an abstraction or a nonobjective painting. I hope that you too will investigate the possibilities that TV has to offer, and bend them to your own way of working.

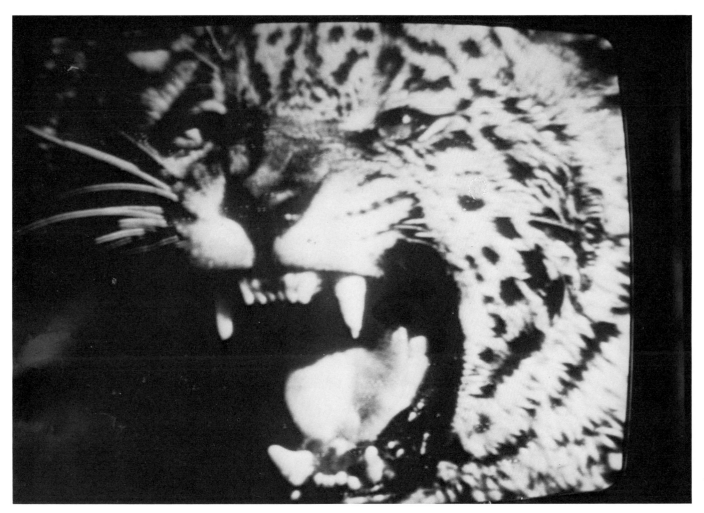

1. The Photo from the TV. This was taken by my photographer with the Nikon, and even if some detail is lost in the shadows, it's a very good photograph for this purpose. My first thought was to have it photostated so I could paint right over it and perhaps add the rest of the body by consulting a *National Geographic* or some other source. But I decided to draw just the head of the fascinating beast, for more impact, and to add later whatever background would be suitable.

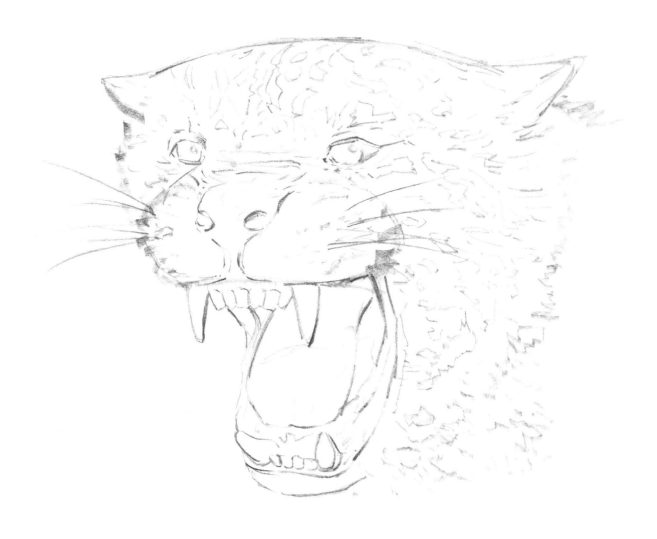

2. The Line Drawing. I tape a piece of tracing paper 6¼″ × 9¾″ (15.8 cm × 24.6 cm) over the photo and with an office pencil, outline what I can. Then I remove and tape the outline to a white mounting board. Studying the photo closely, I add the detail lost in blackness—the top of the head and the bottom of the chin. To stress the threatening snarl, I felt that both eyes should glisten, and that no detail in the mouth should be lost. I'm pointing out my corrections here; you should also research and rectify whatever adjustments your own photos may need. Whenever you take a picture from the television, you'll probably get something with illegible areas too, so be sure to bring them out and let them "read" clearly. And, as I've mentioned—add, delete, subdue, and accentuate to strengthen your painting.

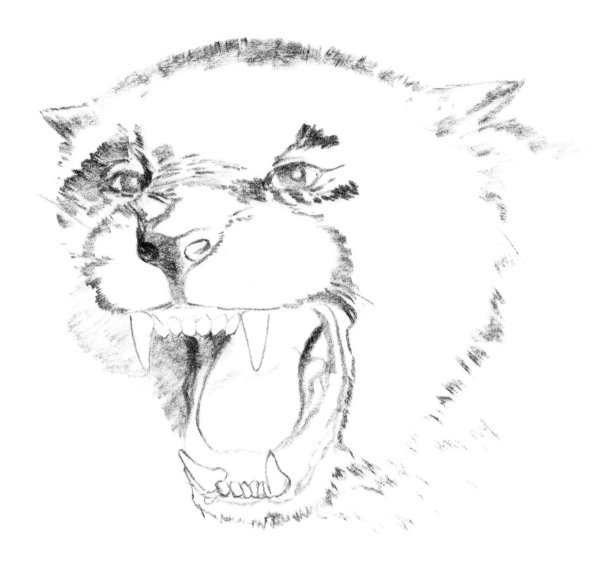

3. Rendering the Main Elements. Now with a General 4B charcoal pencil No. 557, I begin the rendering on a new sheet of tracing paper taped over the line drawing of Step 2. I sharpen the pencil with a matknife (pastel, carbon, and charcoal pencils break in the sharpener) and then work it to a sharp point on a sandpaper pad. I hold the pencil in the conventional manner to do sharp details on the teeth, eyes, nose, and tongue, but switch to the "under the palm" position for the fuzzier details. I'm not applying much pressure yet, so if anything is unsatisfactory, I can easily tap it off with a kneaded eraser.

B

A

C

4. The Background. The completed head (A) as you see it here without a background, looks too much like a poster, so now I'll arrange the proper setting. I place yet another sheet of tracing paper on top of the completed drawing, taking care not to smudge the charcoal. Riffling through some *National Geographic* magazines, I find various backgrounds and try a few sketches. My first sketch (B) I discard as awkward and uninteresting. Looking at my next sketch (C), I make a note to retain the shape of the television screen, but I think the background is too woodsy and lyrical for the subject. A more exotic background (D) doesn't work either. It looks as though the head has been cut out and pasted onto just any picture. Putting aside my sketches, I decide to try sketching the cat in a more immediate setting. In sketch E, the cat looks ready to pounce from a tree. I like the "movement" of the diagonals, as opposed to the "quiet" of horizontal or the "stability" of vertical settings. I tilt the head, too, for still more action.

D

E

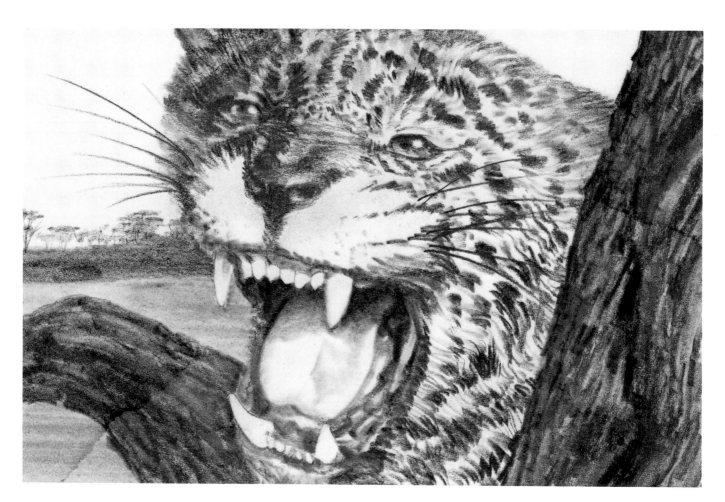

5. The Finished Drawing. I did all the previous attempts on top of the head (it could be clearly seen through the tracing paper I was using) with the same charcoal pencil but when I got what I wanted I switched to the office pencil so the charcoal wouldn't smear the back of the paper where I'd drawn the head. Checking again the *National Geographic* magazines, I find a photo of the flat-topped trees that are so typical of the African landscape, and also a closeup of the bark. When the drawing is finished, I take a paper stump and subdue the bark so it won't detract from the crisp markings on the cat's fur. Then, I just lightly stroke the charcoal picked up by the stump into the middleground, indicating the river. I add the last touches — the whiskers — with the sharp point of a charcoal pencil. I then fix the drawing with Eagle matte-finish fixative.

Abstract Design from Photographs

I'd first like to qualify the heading of this project. It must be presented in this manner because the subject of the book is the use of photography, but let me stress that the basic abstract design is also adaptable when using sketches and studies as the source of information. They too must be hammered into shapes that conform to strong and vigorous designs. The artist who responds to shapes, and relies primarily upon them to convey his message, must solve their disposition in the preliminary steps of the job. The idea is to project clearly and forcefully in visual terms and using the simplest symbols—with no reference material—the mood or the situation he has in mind. It can be happy and carefree, light and playful, exciting and explosive, dark and gloomy, peaceful and tranquil, or ominous and dramatic. Of course, the shapes can be only decorative, with no more purpose than to delight the eye. It all depends on you.

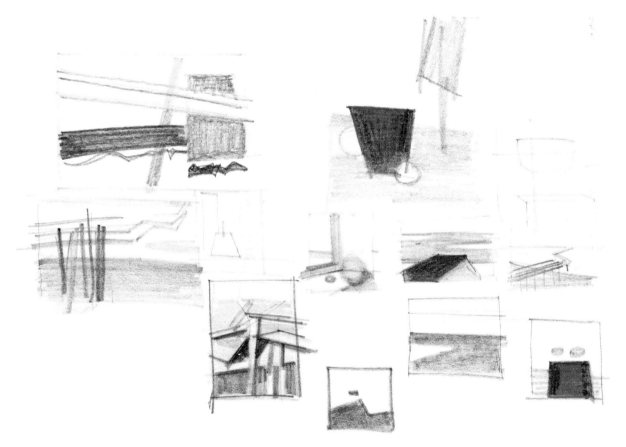

1. Abstract Design Roughs. Here are some roughs done with an office pencil on tracing paper to demonstrate the important role that shapes play in a picture. Some are things I remember having seen, reduced to stark simplicity and others are purely imaginative arrangements for which I'd have to find a subject to fit the shapes, while still others are ensembles of various photographs. Any of these designs can also become the foundation for a realistic painting, which would be all the more forceful because of its strong underlying abstract structure. But enough words—let me show you.

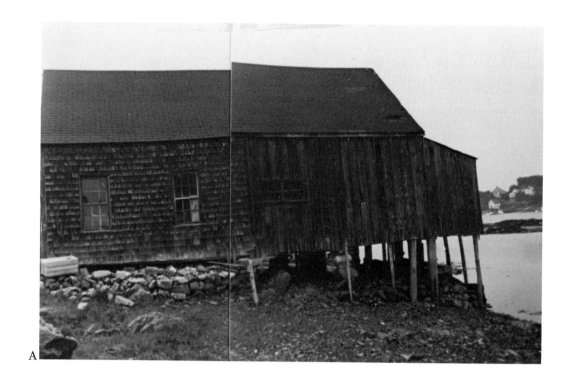

A

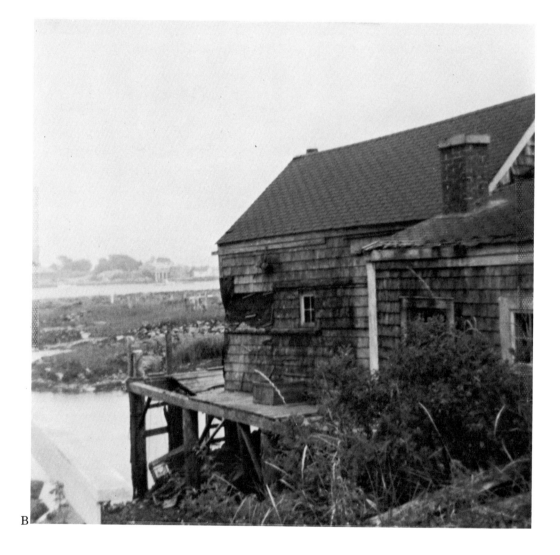

B

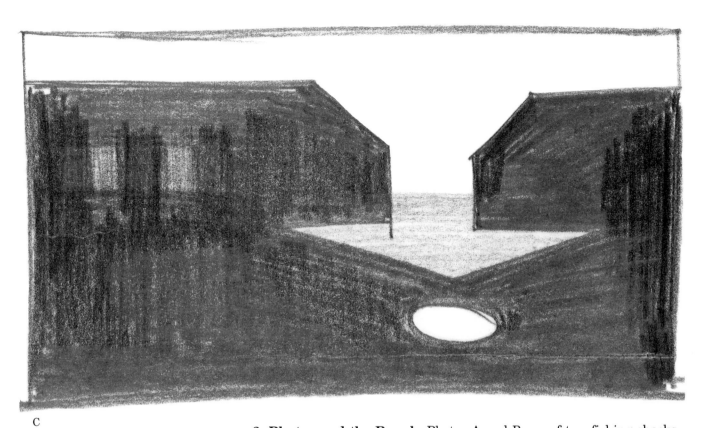

C

2. Photos and the Rough. Photos A and B are of two fishing shacks that I snapped at Cape Porpoise, Maine. The combined backgrounds of these two photos make an obvious downward-pointing arrow; I just have to exploit such a terrific thrust. I dash off sketch C, visualizing the arrow's "target" as perhaps a couple of figures, a flock of gulls on the ground, or maybe a boat—anything that would be plausible with the surroundings. I want just the right element—one that will strike a chord in the viewer.

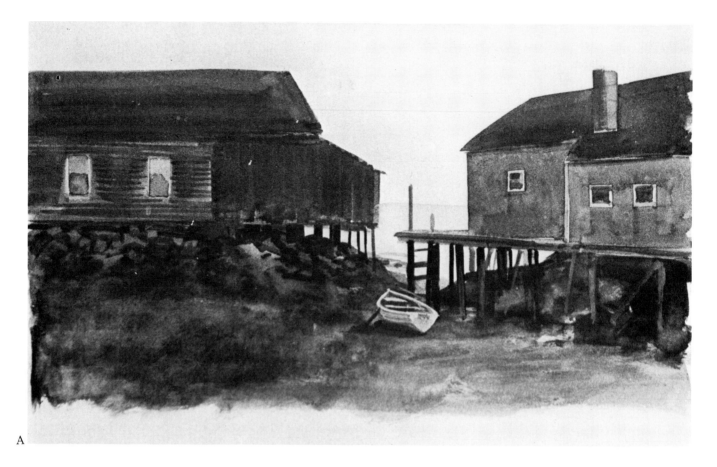

A

B

3. The Sketch. The most exciting part of a painting is when it's being born—pity it's over so soon. The sketch (A) is small, only 6″ × 9″ (15.2 cm × 22.9 cm), done in black watercolor with Nos. 3 and 5 watercolor brushes. I've faked the base of the shack on the right, thinking of some accumulated odds and ends that I'll find later. But my main concern at the moment is the disposition of the main shapes and their values. The question of the arrow's target was settled when I found this photo (B) among my Instamatic shots. I took the foreground boat and sketched it in. Notice I've slightly changed its perspective to conform with that of the buildings. I think I'll shift it down a bit more when I do the drawing.

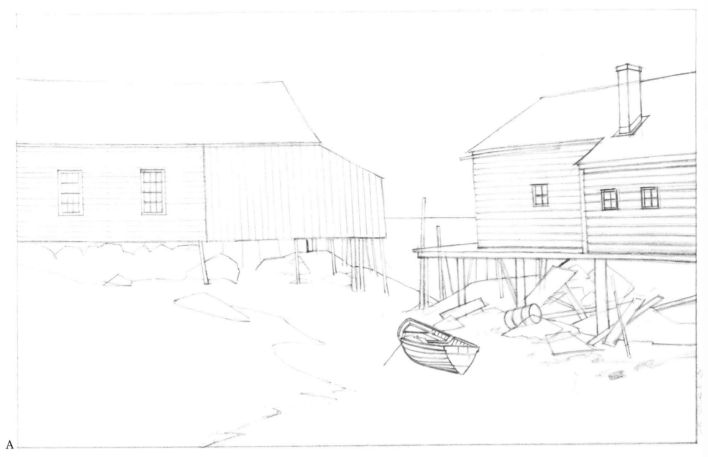

A

B

4. The Line Drawing. Using the squaring-up method, and with an office pencil on tracing paper 12″ × 18″ (30.5 cm × 45.7 cm), I enlarge my sketch to a drawing (A) 9″ × 14½″ (22.9 cm × 36.5 cm). Notice how I've adjusted the perspective of the building on the right so it relates to the one on the left, and how to relieve the monotony of the rooftops, I've extended the chimney into the sky. Looking at the original photographs, I decide the shack on the right is a bit too busy, so I simplify the roof to just one plane and eliminate the bush. Now I need something convincing and authentic for the stuff under the dock. I sift through the piles of snapshots I have around the house and find photo B. I change it, as you can see, almost beyond recognition—but without it, I couldn't have given the area a sense of veracity.

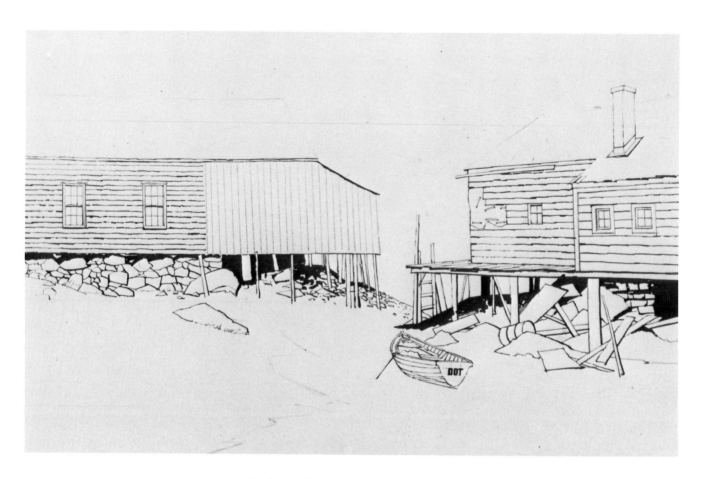

5. Securing the Drawing. Let's try here a combination of media that many artists find most rewarding. After I transfer the line drawing to an illustration board 15″ × 20″ (38.1 cm × 50.5 cm, I secure the line with Artone (Extra Dense) Drawing ink and a Guillott No. 303 drawing pen. Then I do the larger black shapes with a ruling pen, holding it under the palm of the hand so the blades are almost parallel to the painting surface, and spreading the ink in large swaths. These areas could also be done with a brush, but the ruling pen gives me blacker blacks.

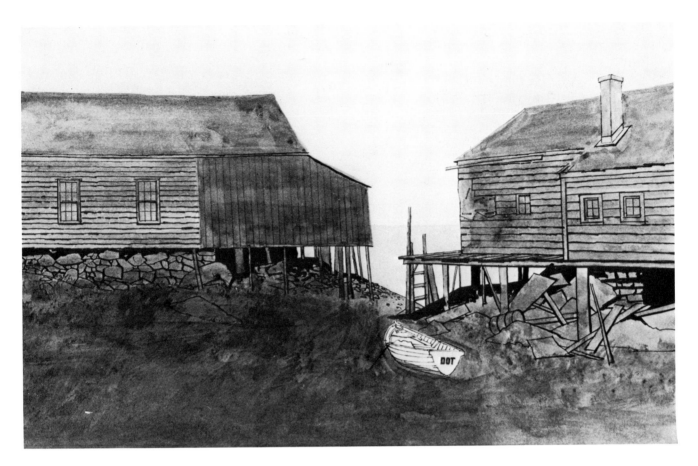

6. Application of Tone. On the butcher's tray I dilute a couple of drops of ink with water. I turn the drawing upside down, and using a No. 20 flat sable and broad horizontal strokes, I give the sky a light gray tone, beginning at the horizon and continuing all the way down to the edge of the picture. Turning the drawing rightside up, I wash a darker tone over the sides of the buildings, without fear of disturbing the ink lines I drew in Step 2 because they're indelible. Next I do the roofs, rubbing and tapping the No. 5 brush on the painting surface to avoid a smooth, even tone, and to establish their dilapidated condition. Notice that I've left the rooftops outlined in pencil; this is because I don't want a dark ink line against the sky. I check both the sketch and the photos as I apply the tones to the buildings. Mixing the exact value you need is only a matter of varying the proportions of water to ink—more water for the lighter tones, more ink for the darker areas.

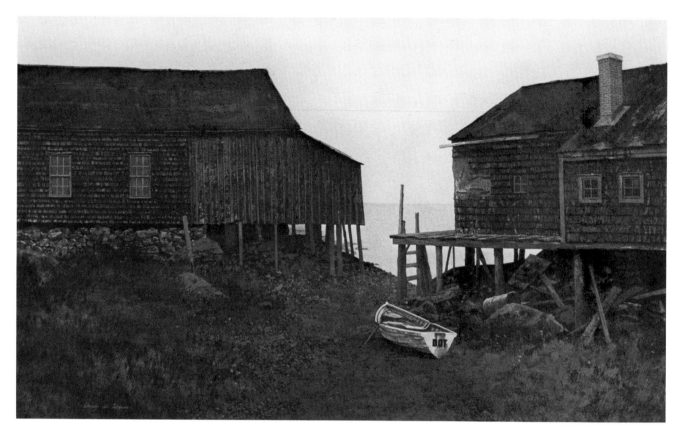

7. Finishing in Opaque Watercolor. I squeeze about half an inch of paint from a tube of Winsor & Newton jet black onto the butcher's tray, and also a spot of yellow ochre and raw umber. I keep handy the jar of Rich Art white. (I need these two colors because the drawing ink grays are warm; to match them, I must add ochre and/or umber to the cool grays I get when I mix only black and white opaque watercolor. I use the side and the heel of the Nos. 3 and 5 watercolor brushes to develop the textures on the shacks and on the ground. In some places, I use very thin pigment so that the underlying ink line isn't obscured; however, I do away with the contours of many elements, especially those of the supporting timbers. The ink has served its purpose — retaining a clearly visible drawing as the painting progresses. And, of course, another advantage of securing the drawing with ink is that if a tonal passage doesn't come off, I can sponge off the water-soluble paint without ruining the indelible ink line, and then start all over again without having to retrace.

To do the bricks on the chimney, I extend the horizon line beyond the borders of the picture, follow the edge of the slanting roof and find the left vanishing point. Then, following the slant of the right side of the chimney I find the right vanishing point. Turning my attention once again to the ground, I bring out some of the pebbles and shale with the point of the No. 3 brush, and then with its side, I smear medium thick pigment over the areas where I don't want any. I finish the boat last with a No. 2 watercolor brush. Notice how I've kept the diffused lighting of the snapshots, staying with close values everywhere except on the white boat, which as the target, should stand out as much as it did in the orignal abstract design. Also, the only ink areas I've retained are the sky and the water, because their flat smoothness serves as a foil to the textures of the motif. (This painting reproduced courtesy of Mrs. Constance Crowell.)

PROJECT 22

Stop-Action Photographs

I doubt there's a time when the camera renders greater service to the painter than when it "freezes" the action of an animal in motion. It was this potential of the instrument that finally, thanks to Mr. Eadweard Muybridge, exploded the myth that a horse had all four legs outstretched when galloping. No doubt it was painful for artists to discard such a cozy convention, but the proof of the photograph couldn't be denied.

1. The Slides. These are the slides as they were taken with the Nikon by my photographer. If the gulls had grouped themselves in a rhythmic arrangement and if the picture had been snapped at that split second, there would be no need of my composing the painting. But since this situation didn't happen, we decided to shoot the birds singly and as close as possible, and later deal with their proper placement. The sun was setting — the time of day when the fishing boats return to Chatham (Cape Cod), and the pier is clouded with hovering birds in pursuit of a morsel. The horizontal sunlight silhouettes the birds against the sky in deep tones and pale golden whites. I knew I had the makings here of a good picture and I could hardly wait for the slides to be developed. Now, look for those bird photos of your own — or go and photograph them — so we can get started.

2. Enlarging with Projector. Using the slide projector, I enlarge some of the gulls, just outlining them on the 19″ × 24″ (48.3 cm × 61 cm) sheet of tracing paper, and shifting to a new spot as I finish each bird. Be on the alert when using slide projections—each element in a group shows the same light angle. If, for the sake of better composition, one or two must be flopped, their lights and shadows should be relocated to conform with the rest of the units. Notice how I'm careful to leave enough space around them, so I can easily cut them out later and rearrange them into their most advantageous positions. (The reason for using the projector this time is that all I need is the line drawing; I will work out the composition and the photos themselves will provide form, texture, and color when I begin to paint.)

3. Working out the Composition. Now I take the separate drawings and begin shifting them around looking for directional thrusts and rhythmic movements relevant to the subjects. As I move the drawings about, I keep an eye on the positive shapes of the birds as well as on the negative shapes of the sky, so that they work together to give me the sense of buoyancy I'm trying to achieve. I'm also careful to avoid bad tangents that occur when the shape of one bird is confused with the contour of another. When I overlap the three gulls on the left for the large shape I need, I tape them to a piece of matboard, then go on to secure the others in the same manner. So I won't lose the arrangement, I place another sheet of tracing paper over it and outline the group. The drawing is 11½″ × 17″ (29.2 cm × 43.2 cm), and I've "hung" the birds from the top to reinforce a feeling of suspension.

4. Beginning to Paint. My support this time is a piece of chipboard, double thick, toned with a blue-gray mixed from Liquitex acrylic ultramarine, blue, black, white, and a whisper of orange. I apply it with a No. 12 flat bristle brush, crisscrossing the strokes to let the thick paint simulate a canvas weave. You have to work fast so that the effect can be evenly obtained, before the paint hardens. The upper part of the panel is cool gray and the lower portion is warmed with orange to get the dusky-evening effect. I tape the drawing to the top of the chipboard panel, arrange each bird underneath its respective contour, and trace them all onto the panel with a 9H pencil. Now I begin painting with Indian red, orange, yellow ochre, ultramarine blue, cobalt blue, raw umber, and black from the Marabu opaque watercolor box, and the jar of Rich Art white. I'm using thin pigment and staying in the middle of the tonal scale—neither all the way down to black nor all the way up to white.

5. The Painting Continued. Why opaque watercolor on an acrylic ground? Because I'd like to point out that paintings don't necessarily have to be done on a single medium basis. When a combination of two or three media gets better results, or facilitates the handling, there's no reason why it shouldn't be used, provided the permanence of the painting is not affected. I want the acrylic base here so that I can, should the need arise, wipe off with a wet paper towel any of the water-soluble opaque watercolor without disturbing the waterproof acrylic ground. I'm using very thin pigment and it has a tendency to "bead," but this too is desirable to get those textures, such as the feathers and other soft contours of the gulls, that would be tedious to render. At this stage, I'm still in the middle of the tonal scale. I'm giving depth to the picture by the variety in size of the birds, and by placing warmer color and darker values in the front plane of the painting with Nos. 1, 2, and 3 watercolor brushes.

6. The Finished Painting. From now on it's only a matter of consulting the slides in the Pana-Vue for details and placing the darkest values and warmest colors up front. I emphasize this because when you use your own photos you may be tempted to reproduce their values as they are and not as they should be, to get a three-dimensional illusion on the two-dimensional surface of your picture. Here in the finish, I'm using a bit thicker pigment and I drybrush the soft transitions between light and dark areas, taking advantage of the "canvas weave." I've made some modifications on the light and dark pattern of those gulls that I've turned to a different angle, so the light source remains consistent. During the execution of the work, some of the contours got out of hand, and I was glad I could reshape them by merely removing them with a damp brush.

A Parting Word

And now it's time to take my leave. I remember asking my publisher when I was about to do my first book if I was to stop at a certain number of pages. "No," he said, "The book will end when you have nothing more to say on the subject." His answer still rings in my ears, and I've adhered to it through the books that followed. All that I know about using photographs for painting is here. I hope you noticed there are no pontifications and no decrees; we're all students, and were we to reach a hundred, we still couldn't claim that there's nothing more to learn. Take what I've imparted to you but develop it further. Remember: "grow or die" is the inexorable law of life, and so continue looking into everything concerned with painting—from pigments, canvas, and paper, to cameras, pantographs, and projectors.

Index

Abstract design from photographs, 137–144
Altering values, 81–86

Black and white photograph, landscape from, 96–99
Brushes, 13–14

Camera lucida, 18, 39–43
Cameras, 11, 16
Casein, 39
Combining several photographs, 53–61
Composing your picture, 52–94
Correcting photographic distortion, 87–94

Enlarging the photograph, 26–52
Experimenting with photographs, 129–151

Film, 11–12
Fleeting lighting effects, landscape with, 104–107
Flopping a photograph, 53–54

Gamma grays, 44

Illustration board, 16
Ink, 14

Landscape:
 from a black and white photograph, 96–99;
 night, from a daylight photograph, 108–113;
 with fleeting lighting effects, 104–107;
 with simplified details, 100–103

Matboard, 16
Materials and equipment, 10–19
Modifying color of original photograph, 112–115
Multiple prints from same negative, 68–74

Night landscape from a daylight photograph, 108–113
Nupastels, 68

Opaque projector, 17–18, 33–38

Painting from photographs, 95–151
Palettes, 17
Pana-Vue, 19
Pantograph, 18, 44–48
Peepers, 18

Pencil, 14–16
Pervading color, 97
Photographic distortion, correcting, 87–94
Photographs and sketches, 62–67
Photographs and sketches, portrait from, 120–123
Photographs from television, 130–136
Portrait from photographs and sketches, 120–123

Ruling method, 27

Seascape:
 modifying color of original photograph, 112–115;
 with rapidly changing details, 116–119
Sequential photographs for panorama, 75–80
Shooting source material, 20–25
Simplified details, landscape with, 100–103
Slides, still life from, 124–128
Squaring-up, 27–32
Still life from color slides, 124–128
Stop-action photographs, 145–151
Surfaces:
 canvas, 16;
 illustration board, 16;
 matboard, 16;
 watercolor paper, 16–17

Television, photographs from, 130–136

Values, altering, 81–86
Visual approximation, 49–51

Watercolor paper, 16–17